121546

D1339657

18

Chinese Art IN DETAIL

Chinese
Art IN DETAIL

Carol Michaelson & Jane Portal

THE BRITISH MUSEUM PRESS

HALF-TITLE PAGE: Warm Water of the Dragon River, 1984, detail of multi-block woodcut by Liang Dong (see p. 138).

TITLE PAGES: Fascination of Nature, detail of handscroll painting dated 1321 (see pp. 100–101).

RIGHT: Detail of blue and white porcelain flask, Ming dynasty, Xuande period (1426–35) (see p. 68).

Photography by the British Museum Department of Photography and Imaging (John Williams and Kevin Lovelock)

© 2006 The Trustees of the British Museum

First published in 2006 by The British Museum Press
A division of The British Museum Company Ltd
38 Russell Square, London WC1B 3QQ
www.britishmuseum.co.uk

Carol Michaelson and Jane Portal have asserted their moral right to be identified as the authors of this work

A catalogue record for this book is available from the British Library

ISBN-13: 978-0-7141-2431-5
ISBN-10: 0-7141-2431-1

Designed and typeset in Minion and Helvetica by Harry Green and Peter Ward
Printed in China by C&C Offset Printing Co., Ltd

ST. HELENS COLLEGE

709.51
MIC

121546

OCT 07

LIBRARY

Contents

1

What is Chinese art?

It is probably the case that for most Westerners, the words 'Chinese art' conjure up visions of willow pattern landscapes on porcelain plates and teapots and Chinese wallpaper decorated with flowers, birds and pagodas. These things are, of course, examples of things which were made by the Chinese, but they were made specifically for export to foreign countries rather than for their own use. They were imported into Europe in large numbers from the 16th century onwards and offered many Westerners their first impression of China.

There is, in fact, a great difference between these sorts of works and those produced in Chinese taste for the Chinese market. Moreover, within China itself, there were great differences between works made for the emperor and those made for the scholarly elite, for the ordinary people or for furnishing tombs or temples. One of the great differences between Western and Eastern art is the extent to which art reflects the class structure at different times in Chinese history. A distinction began to arise from early times between the amateur and the professional artist, and this was to have a great influence on the character of Chinese art in later times.

Many works of art were actually objects which were put to use every day, while others were stored away and only brought out on special occasions. In China there was an accepted traditional hierarchy of materials and techniques used to produce works of art. At the top of the hierarchy were calligraphy and painting, closely followed by jades and bronzes. All these were associated with scholarly taste and a reverence for antiquity. Below these came decorative arts such as lacquer, porcelain and silk. Sculpture was always somewhat separate, reserved for religious and funerary use.

Cloisonné enamel decoration of an imperial dragon on a large metal lidded jar. Ming dynasty (1368–1644).

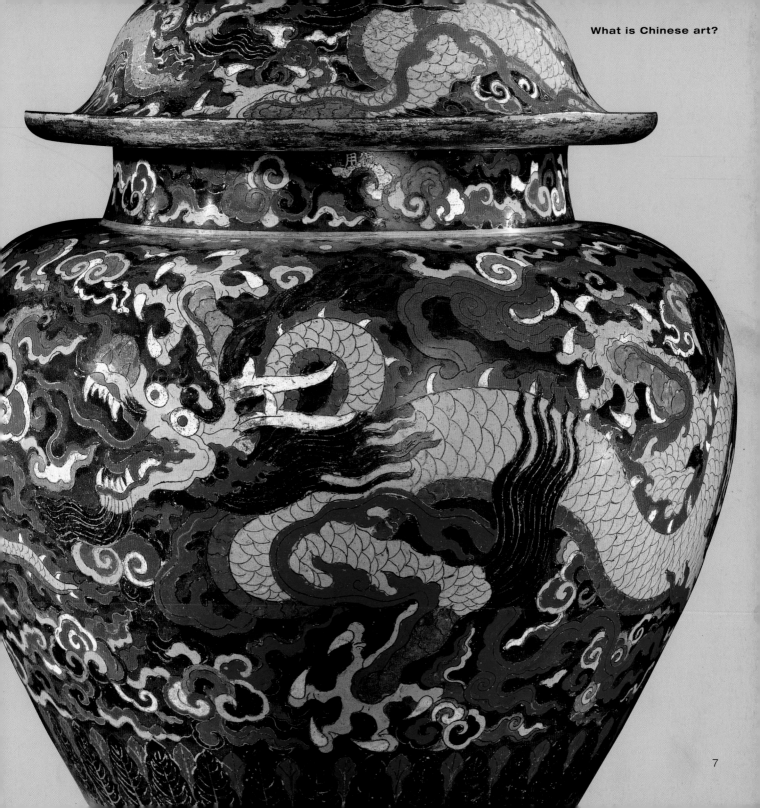

Arts of the brush

It is perhaps difficult for Westerners to appreciate the way Chinese value the art of calligraphy, especially since we cannot understand the words or characters being drawn. It is not only the brush strokes which are thought admirable, but also the fact that calligraphy was used by scholar-officials and reflected the high status of official life. Based originally on the square script used on bronze inscriptions, a huge variety of different styles of script developed, some very regular and some extremely cursive and almost illegible. The equipment needed for calligraphy in China is the same as that for painting, and the basic four items have been called the 'Four Treasures of the Scholar's Studio' or *wenfang sibao*. They comprise paper, brush, ink and inkstone. To produce liquid ink, the cake of ink (made of soot and glue) is ground against the surface of the inkstone and water is gradually dropped on to the stone from a water dropper, gathering in a well at one end of the stone. The brush (usually made of bamboo and animal hair, with a pointed end) is then dipped into the well, and the depth of intensity of the ink depends on the wetness or dryness of the brush and the amount of ink on the brush.

In China, painting, poetry and calligraphy are closely linked and are called the 'Three Excellences'. Men of culture would be accomplished at all three, and calligraphy and poems often appear on paintings. Writing on paintings sometimes describes how or when the painting was produced or for whom. It may also be in the form of a comment or colophon by a later artist or collector of the painting, giving their views about its quality or significance. Seals of the artist or of collectors of the painting can be stamped in various places, usually in red ink. Seal script is stylized and geometric as it is carved in stone, and this can make it difficult to decipher. Famous names can add to the value of the painting by their association with it.

Chinese painting is quite different from brightly coloured Western oil painting because it is painted predominantly in ink on paper, with a small amount of water colour. It is also not framed or glazed but mounted, in different formats such as hanging scrolls, handscrolls, album leaves and fan paintings. Unlike in the West, paintings in China were not displayed permanently but were rolled up and put away, only brought out for special viewings. This is partly due to the delicate nature of the ink and colour which would fade easily if left exposed to light for a long time. Connoisseurs would not view the

painting from a distance, as in the West, but would approach close to the painting, in fact 'reading the painting', as expressed in the Chinese phrase *duhua*. There is also little need for extensive knowledge of mythology or religious doctrine in order to understand most Chinese paintings, as the subject matter is generally self-explanatory.

Associated with Daoism and ideas of *yin* and *yang*, landscape painting is at the top of a hierarchy of subject matter for paintings and has long been the most popular subject, linked with refined scholarly taste. However, in early Chinese painting, before the 10th century, landscapes were not so important and the human figure was more dominant. This was partly due to the influence of the philosophy of Confucianism, which emphasized humans and their values. The Chinese term for landscape is literally the two characters meaning 'mountains' and 'water'. The land-scapes depicted, however, are not topographic records of real places visited by the artists but imaginary, idealized landscapes of the mind. Mountains have a spiritual resonance in China as abodes of higher powers: looking at paintings of mountains is therefore good for the soul. Below landscape painting in the traditional hierarchy come figure painting, bird, flower and insect painting and religious painting.

The aesthetics of painting and calligraphy

have had a great influence on the other arts. In the motifs that adorn ritual bronzes or the flow of drapery over the surface of Buddhist sculpture, in the decoration of lacquer ware or pottery or cloisonné enamel, it is the rhythmic movement of the line, following the natural movement of the artist's or craftsman's hand, that largely determines the form and gives to Chinese art as a whole its remarkable harmony and unity of style.

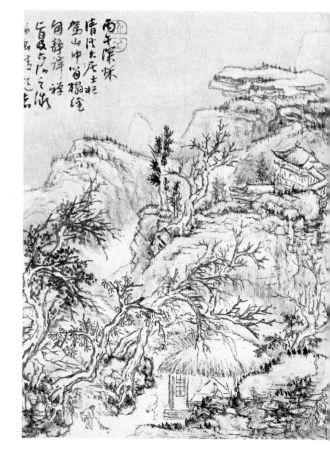

OPPOSITE

Kuncan (1612–73), Winter, dated 1666. Detail of album leaf mounted in handscroll form, ink and colour on paper.

Precious objects

In contrast to the West, where diamonds, gold and silver have usually been highly valued, in China bronzes and jades were preferred. Bronzes and jades were used from very early times in China for ritual and burial, and were thus associated with the elite. In later China, they were collected by scholars and became symbols of good taste, due to their associations with antiquity. Since the 10th century there has been a great reverence for antiquity and this resulted in the collecting and cataloguing of ancient bronzes and jades by the elite and by emperors.

Bronzes were valued originally because they were bright and shiny, in the same way that Westerners valued gold. The greenish colour we see today is a result of age, due to the copper content of the copper-tin alloy of which they are made. Cast using ceramic piece moulds, ancient Chinese bronzes were originally based on ceramic shapes but developed a huge variety of complicated vessel shapes, decorative motifs and techniques, as well as being made in very large sizes and in sets. Later archaistic bronzes were smaller in size and less dramatic in decoration, as their function changed from being used for ritual food and wine for the ancestors and being buried in tombs to being placed on a scholar's desk as an ornament, or

being used in Buddhist temples as altar vessels, candlesticks or flower vases.

As far as Chinese jade is concerned, most Westerners probably immediately think of bright green jadeite, which actually came from Burma and was imported into China from the 18th century and used for jewellery and carvings. However, it is the paler nephrite from Chinese Central Asia that was prized and used from the Neolithic period in China for producing ritual or ceremonial objects. Ancient jade ritual weapons and tools were copied in later China, produced for collectors who valued their shapes because of their link with the ancient past.

China is, of course, synonymous with porcelain, due to the very high regard in which Chinese porcelain was held from the time that Westerners discovered it in the 16th century. The blue and white plates and dishes which appeared in Western houses and paintings from this time onwards were again made mainly for export, while the Chinese preferred more subtle designs. It was only later that we in the West became aware of the refined shapes and glazes of Song dynasty wares, for example.

Porcelain was made in huge quantities in China using mass-production methods at one main centre – Jingdezhen – in south China. In

Detail of flowers in a silk and twill textile from cave 17 at Dunhuang. Tang dynasty (9th–10th century).

fact, a single item of porcelain might have been worked on there by up to 70 men, all doing a different task. This highly organized division of labour was developed very early in China, as can be seen, for example, in Chinese ancient bronzes or the vast terracotta army of China's First Emperor, Qin Shihuangdi. The fact that large numbers of bronzes and ceramics survive shows the scale of production in China, which has long had the largest population of any country in the world. At the height of the export of porcelain to the West, at least one Dutch ship would carry 150,000 pieces of Chinese porcelain for export in a single cargo.

Astounding quantities of luxury goods were made in China and their production was usually controlled by the state, in that Chinese rulers controlled the raw materials and set up workshops to supply their palaces with all their needs. As early as the first century AD, lacquer was being produced in well-organized workshops involving many different workers, each with their own job. This can be seen in a lacquer cup which has an inscription listing the names of all the workers involved and all their different functions. Moreover, a lacquer basin dated AD 9 has a serial number 1450 out of 4000 on it. Lacquer, made from the sap of a tree indigenous to the Far East, was valued for being waterproof and insect proof. Decoration could be painted, inlaid, carved or gilded and

in China lacquer was an important craft, used for many things from cake boxes to Buddhist sculptures.

The other form of Chinese art which gave its name to China is silk, since China was known in Latin as *Seres*, the land of silk, due to the export of fine Chinese silks to Rome. Silk production started in China at a very early date, from the Neolithic period, when silk worms were cultivated. Silk was always regarded as a prestigious material and was buried in tombs of aristocratic ladies from the Han dynasty, to furnish them with fine clothes in the afterlife. Self-patterned silks and embroidery were already in production by this time.

Unlike in the West, sculpture has never been regarded in China as an elite art form. Produced by craftsmen and monks for use in tombs and temples, it was somewhat looked down upon by scholar officials. Tomb sculptures, such as the terracotta warriors of Qin Shihuangdi, were mass-produced in modules, with small differences in detail. Buddhist sculptures were a foreign import to China and gradually developed a Chinese style and beauty. The earliest Chinese images of the Buddha in human form were adapted from those of Gandhara, in present-day Pakistan and Afghanistan, transported along the Silk Routes to China, while later Chinese Buddhist art was heavily influenced by Tibet.

Symbols

Materials used to produce beautiful objects in China differed from those used in the West, just as the ideas and beliefs, myths and stories that lay behind them and decorated them differed. Some of the most well known decorative motifs in Chinese works of art have a symbolism that would be familiar in China but perhaps not in the West. The dragon, for example, is known as the symbol of the emperor, but it may not be so well known that this derives from its association with rain-giving and therefore fertile crops. In the West, of course, the dragon is traditionally regarded as fearsome and evil.

Perhaps the most persistent motifs in Chinese art are connected with the quest for immortality and longevity: cranes, peaches, turtles and pine trees all suggest long life to Chinese people. More scholarly motifs include the bamboo, bent in the wind but never broken, thus symbolizing the integrity of a true scholar.

Puns on the pronunciation of Chinese characters are numerous, giving rise to popular motifs such as the bat, which sounds the same as prosperity, or the fish, which sounds like the character for plenty.

Popular novels such as the Romance of the Three Kingdoms or the Dream of the Red Chamber, poems by famous Tang dynasty poets, dramas, operas or folk gods were all illustrated on paintings, woodblock prints and objects which made China quite unlike anywhere else.

Chinese art is distinctive for the shapes of objects produced, materials used to make them, beliefs and philosophies underlying them, motifs used to decorate them and the uses to which they are put. They are concrete expressions of a unique civilization, one which is in fact the longest surviving in the world. While foreign imports and ideas have transformed aspects of Chinese art over the millennia, it is clearly still recognizable as Chinese and is continually developing.

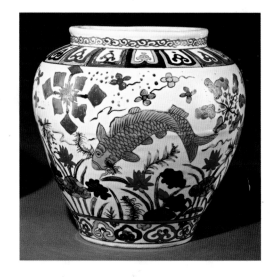

OPPOSITE

One of a pair of porcelain jars with underglaze blue and overglaze enamel decoration depicting fish. Ming dynasty, Jiajing period (1552–66).

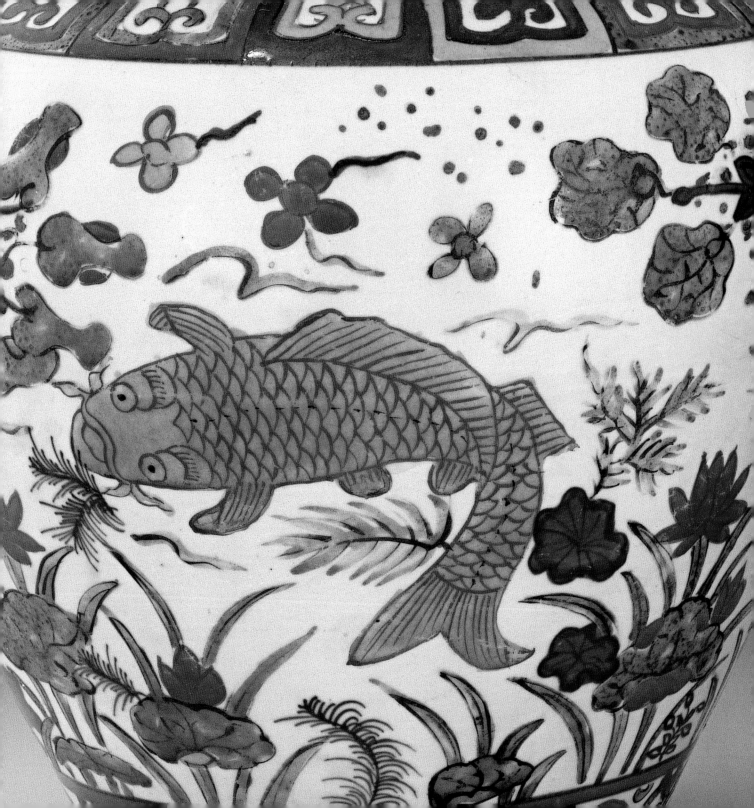

2

Art for the tomb

As in many other cultures, the Chinese buried works of art and treasured objects as well as items of everyday use in their tombs. This was partly in the hope that they would be of use in the afterlife, but also to show the status of the tomb occupant. Sometimes the objects used in burial rituals, such as ritual bronzes, were then buried in the tomb afterwards.

In the tombs of the Shang dynasty (c. 1500–1050 BC), humans and animals were buried along with their royal owners. Later this practice was replaced by the burial of models of humans and animals instead. These were usually made of earthenware, such as the life-size terracotta warriors buried with the First Emperor of China, Qin Shihuangdi.

Models of objects needed for everyday life, such as granaries, pigsties or wells, were included among tomb goods in the Han dynasty (206 BC–AD 220), along with objects which it was thought might help to preserve the body inside the tomb, such as jade suits.

Chinese ideas about the afterlife and paradise were connected with Daoism and Buddhism. The Daoist paradise was thought to be in Penglai, the Isles of the Immortals off the east coast of China. This paradisiacal island was portrayed in mountain-shaped bronze incense burners with holes in the top through which the incense would waft, thus resembling clouds floating over the mountains. Sometimes ceramic copies of these incense burners were buried in tombs, as were lacquer vessels painted with Daoist immortals and strange creatures flying among swirling clouds.

Since the practice of cremation was introduced to China with Buddhism, there is not the same amount of Buddhist art buried in tombs, although wall paintings in tombs often display Buddhist motifs such as lotus flowers. During the Tang dynasty (618–906), fearsome Buddhist guardian figures with bulbous eyes were made of *sancai* (three-colour) glazed ceramics and buried at the entrances of tombs to ward off evil spirits.

Tomb goods showing the status of the tomb incumbent often portrayed animals and people associated with the Silk Routes and the

exotic goods traded along them. Glazed ceramic models of Sogdians and Persians, Jews and Turks, curly-headed black servants, ladies playing polo, two-humped camels laden with treasures and fast horses were all buried in tombs of the Tang dynasty, when this trade was at its height.

The structure of tombs changed over the centuries, from simple shaft tombs with all the burial goods enclosed in wooden boxes, to chamber tombs, with painted walls resembling houses. The wall paintings are fertile sources of information about clothing, jewellery, hairstyles and ceremonies. In later tombs, such as that of the Ming emperor Wanli, sumptuous jewellery, costumes, headdresses and porcelains were buried. During the Ming dynasty (1368–1644), models of entire houses made of earthenware were also buried, as well as miniature tables and chairs, set out for a banquet with realistic-looking dishes of food and drink.

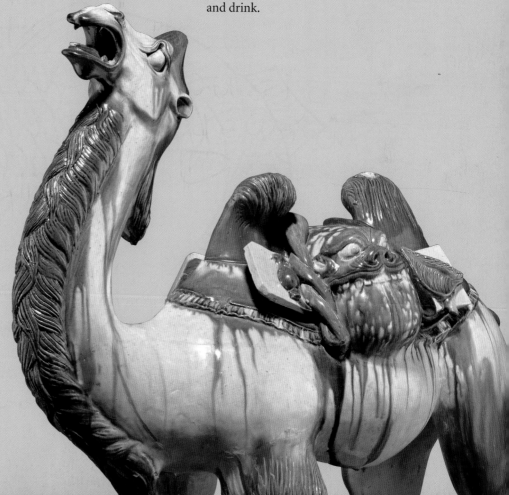

Sancai (three-colour) ceramic tomb figure of a camel. Tang dynasty (618–906).

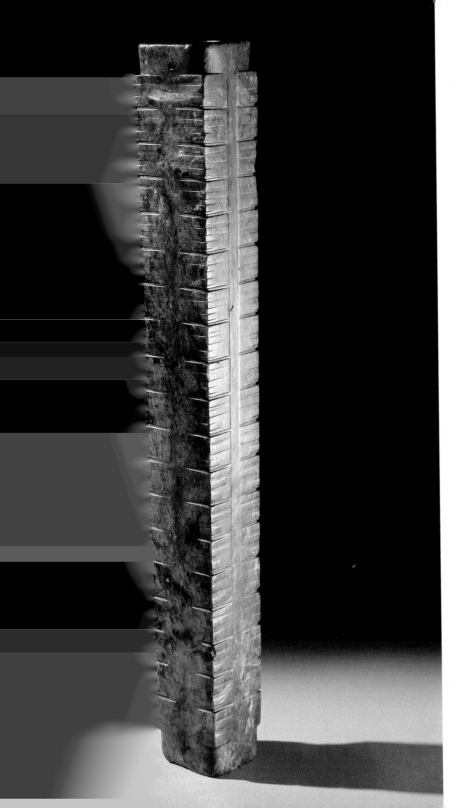

Jade *cong*, Neolithic Liangzhu culture (*c*.3000–2000 BC).

This tube-like jade was made in the Neolithic period, before the age of metalworking. In southeastern China jade was used for ceremonial purposes and buried in tombs. The *cong* are often found aligning the body in the grave, but as there is no writing from this period we don't know precisely what functions these jades may have had. The principal jade shapes of the Liangzhu people were a disc, later known as a *bi*, and a tube of square cross-section pierced with a circular hole, later referred to as a *cong*.

The corners of the Liangzhu *cong* are decorated with faces. Two types of face are found, one of which can be quite detailed. On these tall *cong*, however, the faces are very sketchily drawn, using circles and bars (as shown in the drawing) to suggest facial features. Jade cannot be carved but must be abraded and it would have taken a craftsman many months, if not longer, to work this jade – emphasizing how special its purpose must have been.

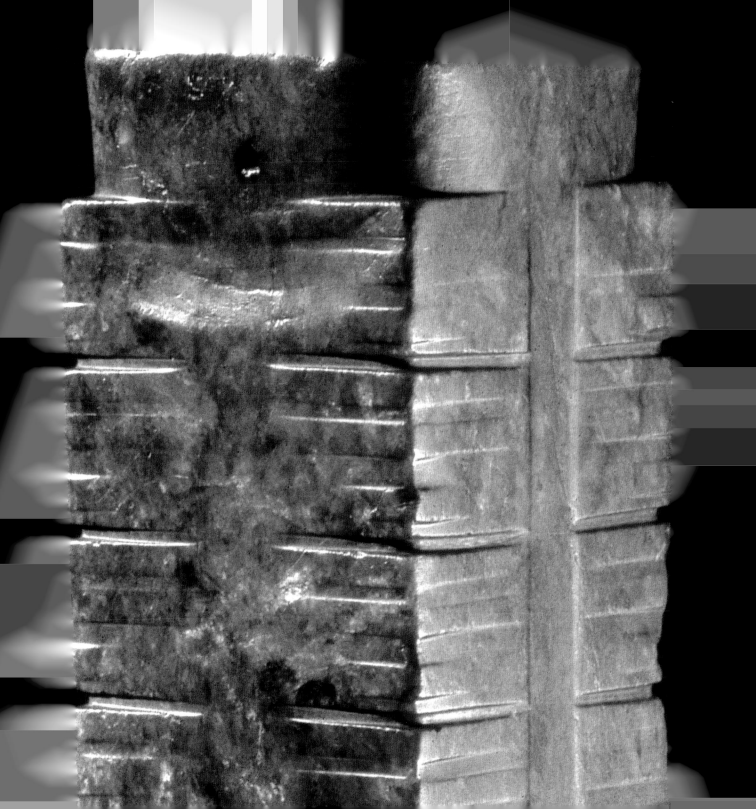

Bronze *hu*, Shang dynasty (*c*.1500–*c*.1050 BC).
The Bronze Age in China began around 1700 BC, and many of the early bronze shapes were similar to contemporary ceramics. This *hu* is a wine vessel which would have been used for sacrificial rites dedicated to the ancestors. If there is an inscription on the early bronzes, as there is on this one, it is generally short. This inscription consists of a pictograph of a hand holding a staff above a boat. The background motifs of tight spirals (*leiwen*) and quills belong to the late Shang period of about 1200 BC.

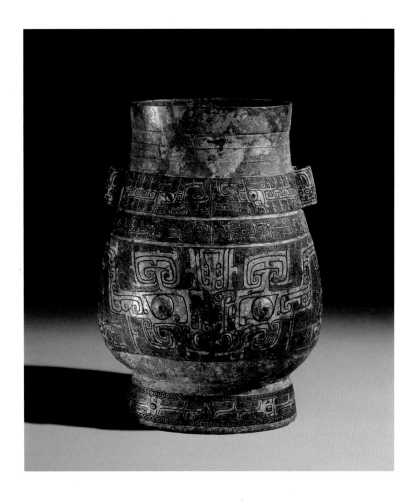

The principal motif on this *hu* is the large mask-like feature referred to as a *taotie*, meaning a monster or a glutton, although this term was not used until many centuries later. The *taotie* appears once on the front and once on the back of the vessel and has enormous compelling eyes. Horizontal bands and quills lying either side of the eyes now read as a body, repeated twice for reasons of symmetry. It is possible to see quite clearly the monster's nostrils as well as its bottle-horns, fangs and mouth.

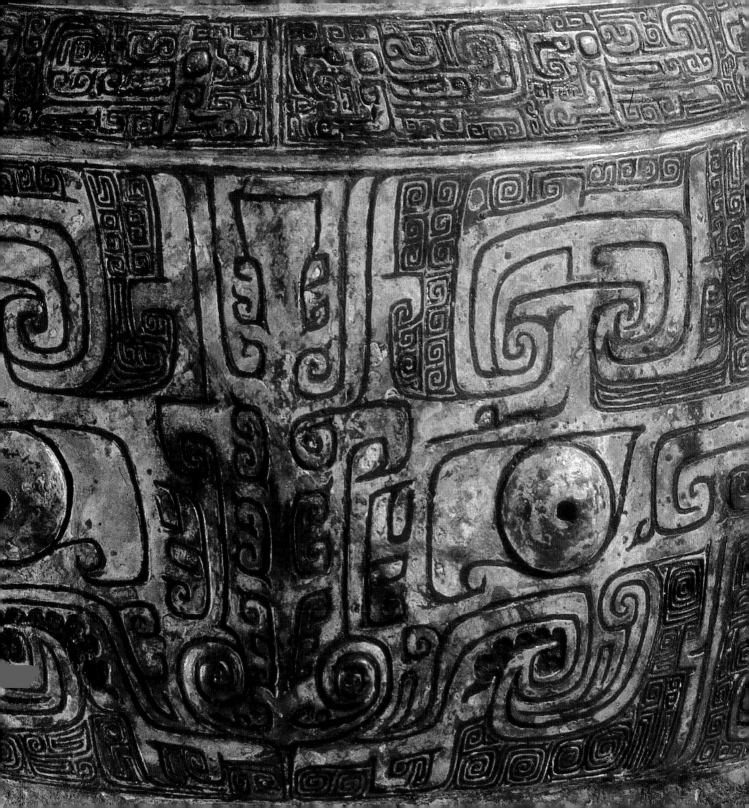

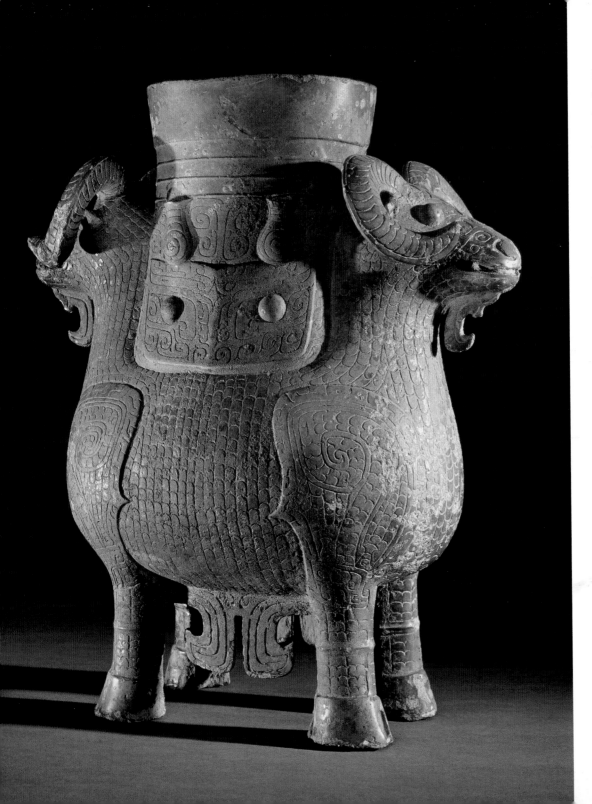

Bronze *zun*, in the shape of two rams. Shang dynasty (*c*.1500–*c*.1050 BC). This is probably one of the most famous of the British Museum's bronzes. It was made for wine and is flanked by the heads and forequarters of two rams. The rams are very lifelike and convincing with their freely curling horns. The ram's bodies are covered with small scales and two dragons with small bottle-horns are embedded among the scales. This realistic animal shape is very different from the metropolitan-style bronzes made in the Shang dynasty and is thought to have come from the south of what is today Hunan province.

The flanges at the sides of the bronze represent the rams' beards. The horns were probably cast first and then inserted into the moulds used for casting the rest of the vessel, and the beard hides some of the mould's seam marks. The *taotie* seems to have been less important and perhaps less well understood in southern China than at Anyang, in Henan province in northern China, which was the major centre of the Shang dynasty from about 1300 BC. There is a *taotie* on this *zun*, below the lip of the container. Its eyes are clearly protruding, but its other features are just a maze of lines.

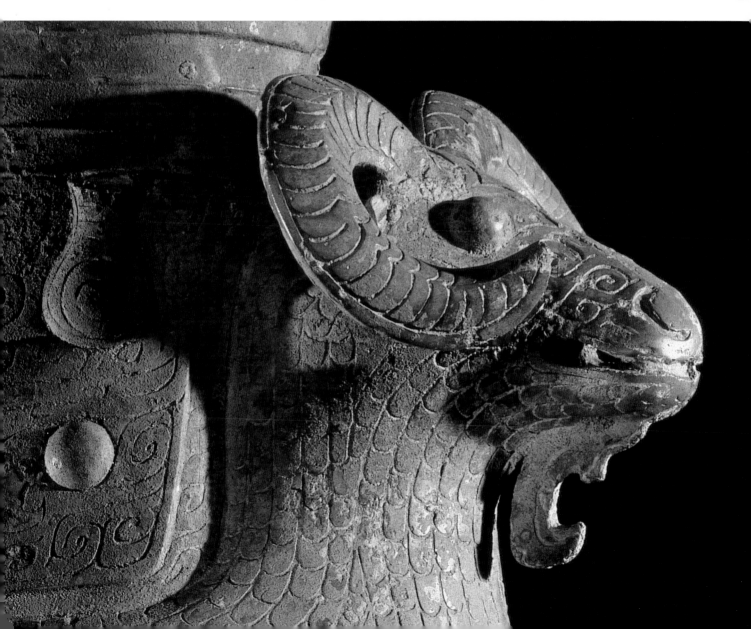

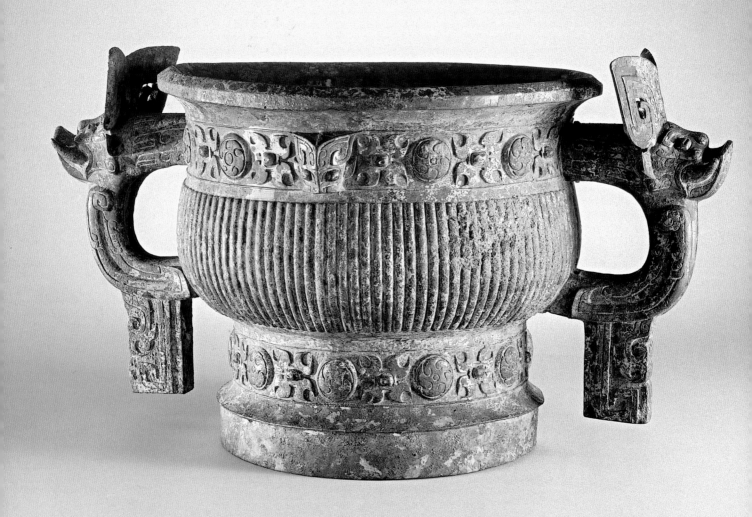

Bronze *gui*, known as the *Kang hou gui*.
Early Western Zhou dynasty (1050–770 BC).
This *gui* is a ritual food vessel used in the rites for
worshipping the ancestors. It has a high foot-ring
and large handles of tusked animal heads with
upright horns, swallowing birds whose beaks just
emerge from their jaws; below the handles are
decorated with birds' wings, bodies and tails.

This *gui* is famous for its inscription, which is
written in the centre of the interior of the vessel
and was intended to be seen by the ancestors for
whom it was made. The inscription records a
rebellion by remnants of the Shang and its
successful defeat by the Zhou. It relates that the
Zhou king Wu's brother, Kang Hou (Duke of Kang)
and Mei Situ Yi were given territory in Wei (in
Henan province) in recognition of their defeat of
some Shang rebels. Such bronze inscriptions
form very important historical records for this
period.

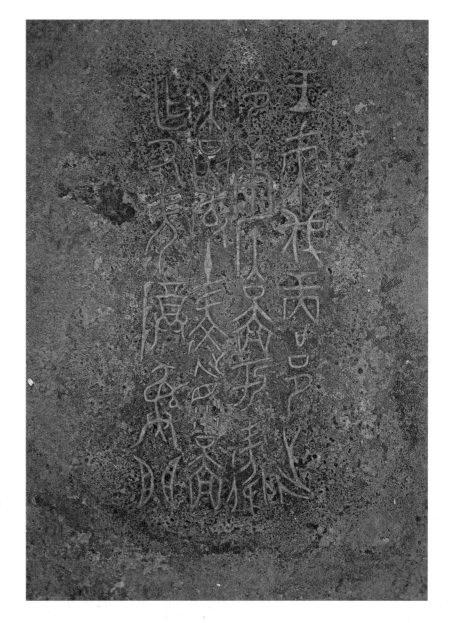

Ceramic incense burner.

Han dynasty (206 BC–AD 220).

This earthenware model of an incense burner has a green lead glaze. The top is in the shape of a mountain, and around the sides animals prowl through a hilly landscape. During the Han dynasty a new interest in landscape emerged which became a recurrent feature of Chinese art. There are many poems written at this time celebrating the royal hunts that took place in the imperial game parks as a formal display of imperial power. Mystics who sought immortality would retreat into the isolation of a beautiful landscape. This pottery burner would have been a later version, for burial only, of earlier bronze incense burners.

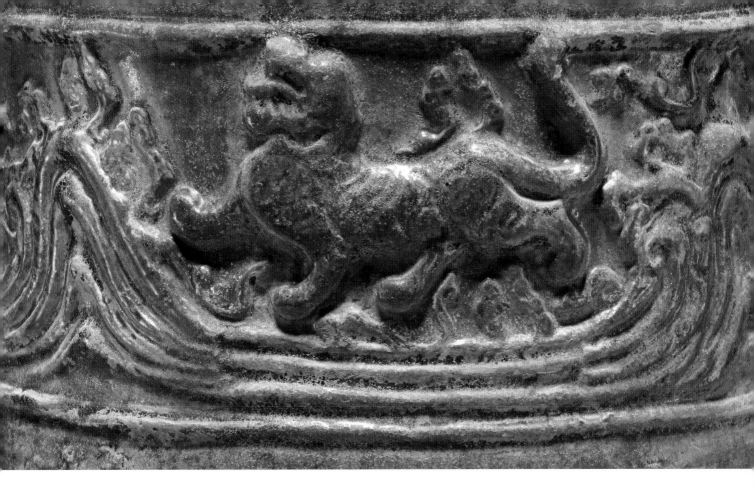

It seems that people hoped, if they achieved immortality, they would rise as adepts and wander among mythical animals, such as the tiger or chimera shown here. The swirling, painterly style of landscape portrayed on this burner is moulded with Daoist motifs beneath the lead glaze and resembles that on contemporary lacquers. The mountain-shaped lid of the censer refers to the sacred dwellings of the immortals. The Kunlun mountains were considered to be located in one of the two main paradises where it was thought the immortals lived, ruled by the Queen Mother of the West. The tiger and hills shown here are comparable in style to those woven in the brocades of the period. On the original bronze incense burners there would have been holes from which the incense would have swirled out, imitating the cloud formations over the tops of mountains.

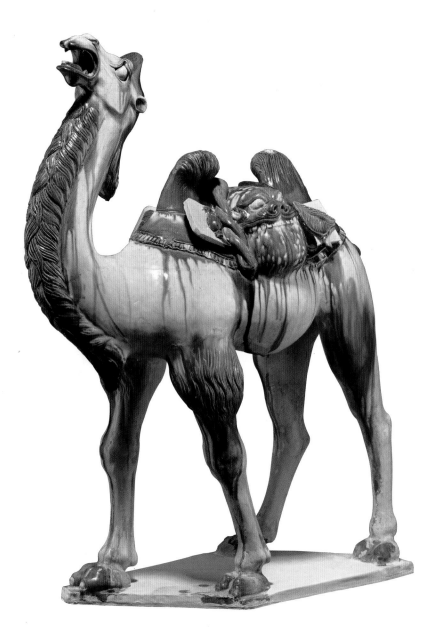

***Sancai* (three-colour) ceramic tomb figure of a camel. Tang dynasty (618–906).**

This camel is part of a group of thirteen tomb figures said to have come from the tomb of a general who died in AD 728 and was buried at Luoyang. The use of *sancai* wares in the north was subject to social restrictions, so the discovery of glazed figures in a tomb is a clear sign of the status of both the ceramics and the deceased. Earthenware figures formed part of the funerary procession and were displayed on carts, the number and size of the figures determined by the rank of the deceased. The figures were moved into the tomb after the coffin was placed inside the burial chamber.

The camel's humps are laden with the types of goods, including a pitcher for carrying liquid and some meat for the journey, that they would have carried over the Silk Route, which was at its height during the Tang dynasty – one of the most cosmopolitan periods in Chinese history. The saddlebag clearly shows a 'monster' mask, perhaps to frighten off danger. The resilient and cantankerous Bactrian camels plied these difficult trade routes across vast expanses of inhospitable terrain, carrying up to 120 kg of cargo. China exported luxuries such as silk, lacquer ware, bamboo products and steel and imported perfumes, horses and jewels from the Western world.

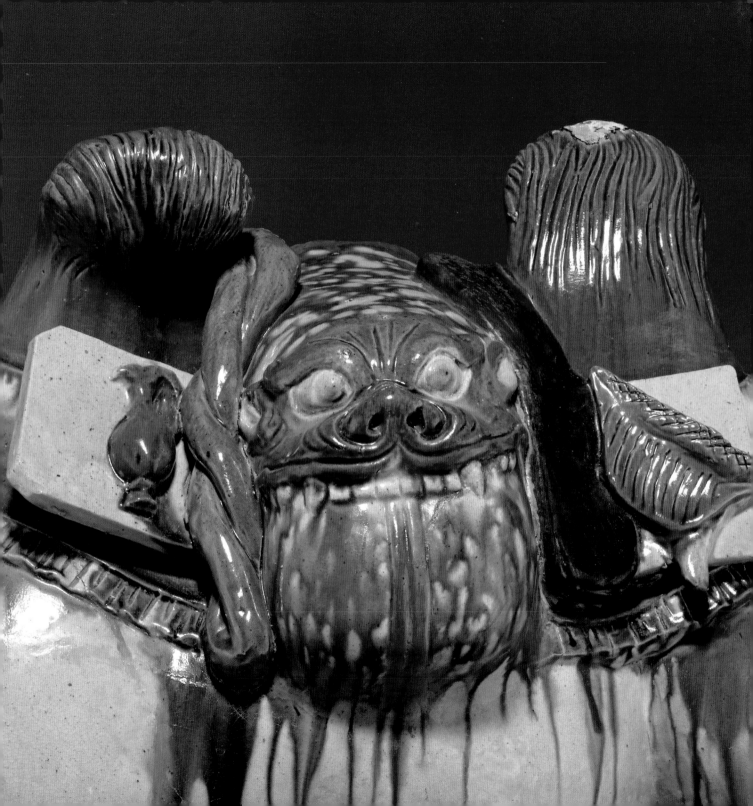

Sancai (three-colour) ceramic tomb guardian figures. Tang dynasty (618–906).

Tomb guardians were placed in Chinese tombs from at least the Han dynasty. These figures belong to the same set of burial sculptures as the camel on the preceding pages. They would have been made specifically to protect the tomb occupant from malevolent forces. The *sancai* glaze contains the oxides of various metals such as iron, zinc, copper, cobalt and manganese. In the firing these were transmuted into rich tones of yellow, green, brown and blue. Many of these protective figures, beasts and demons were extremely substantial and lifelike and often included models of Confucian officials, intended to confirm the rank of the deceased to the officials of the afterlife.

Human-headed tomb figures would have been placed with Buddhist *lokapala* figures to guard the body in burial. Eyes glaring, they bare their teeth in a furious grimace and sink their claws into the ground. Such beasts are ferocious, with spiky wings, weapons such as a halberd, and long horns protruding from behind their heads.

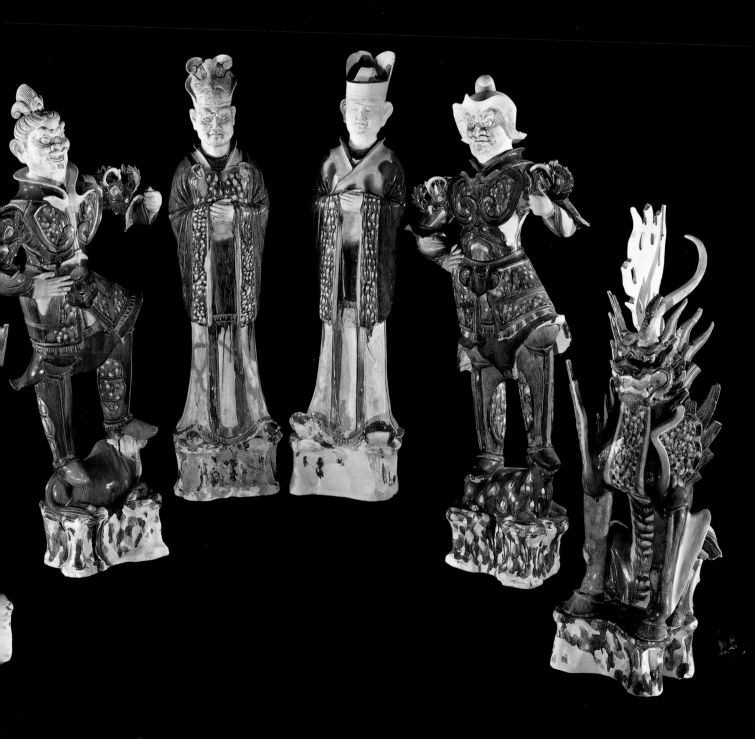

Earthenware model of a Ming housing complex. Ming dynasty (14th–15th century).
This is an earthenware funerary model of a typical house complex in which many generations of one family would live together. The buildings were grouped around a series of courtyards and there would usually be shared kitchen and washing facilities. The larger buildings provide living accommodation and kitchen quarters and the largest one is the main reception hall. To the rear of the complex is a storehouse, equipped with a lock, where valuables would be housed.

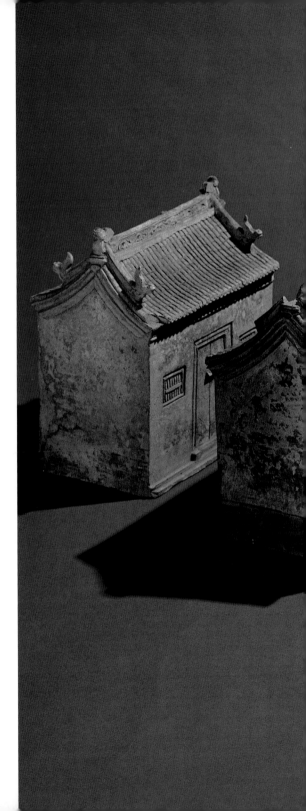

Just inside the ornamental gate, marking the entrance to the complex, is a dragon screen. It was placed there to block the penetration of evil spirits, which were thought to be capable of travelling only in straight lines.

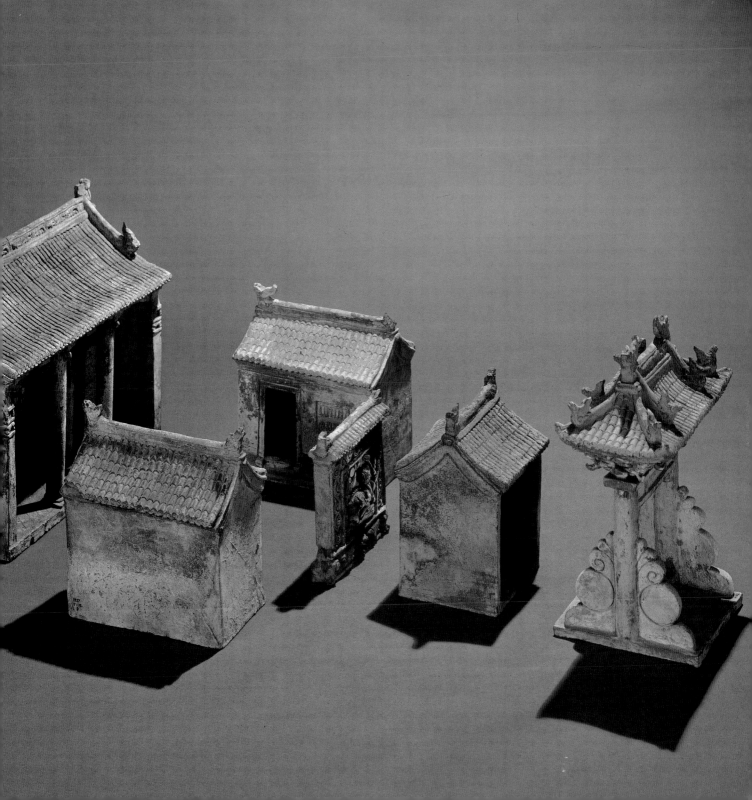

3

Art for the temple

Temples in China could be either Buddhist, Daoist or Confucian. With a pragmatic approach to the popular practice of religion, all three have continued to play their parts right up to the present day.

Temple art was predominantly Buddhist. Sculptures, paintings, manuscripts and utensils were made for the glory of the Buddhist church and the accumulation of merit, which could be achieved by the author, producer or donor of the work through the repetition of the name or image of the Buddha. Buddhist works were produced for individual or communal merit or for the protection of the nation. Large-scale Buddhist cave temple projects were undertaken from the time Buddhism was introduced into China, in the period between the Han and Tang dynasties (220–618). The most famous of these are at Yungang, Longmen and Dunhuang. Hundreds of small Buddha figures can be seen in rows in niches in these cave temple sites, surrounding the more majestic large sculptures of Buddhas or bodhisattvas. Portable statues were also produced in bronze and very large ones in cast iron, as well as more delicate examples in carved and painted wood or in dry lacquer. Sculptures were often inscribed and dated, and this has contributed to our understanding of the development of styles.

Buddhist paintings on silk were less well preserved unless they were rolled up and stored carefully in temples or caves. An example is the hoard of Buddhist paintings found at the Dunhuang cave temple site by Sir Marc Aurel Stein in the first decades of the 20th century. These include paintings of the Western Paradise of the Amitabha Buddha, new-born souls being reborn into paradise out of lotus ponds, and heavenly musicians and dancers, as well as depictions of landscape and architecture between the 8th and 10th centuries. The donors of the paintings are often portrayed at the bottom, wearing the latest fashions in clothing and jewellery.

Later Buddhist art in China was heavily influenced by Tibetan and Mongolian Buddhism. Tibetan lamas acted as spiritual guides to Chinese emperors in the Ming and Qing dynasties, with the result that many *mandalas* (depictions of the cosmos) were

produced, both in two and three dimensions, as well as Tibetan-style sculptures.

Alongside Buddhism, people also practised Daoism. Many landscape paintings from the 10th century onwards show the influence of Daoist ideas about the *yin-yang* balance believed to be at the heart of the nature of the universe. Practising the Dao (the Way) was about understanding the natural order of the world while withdrawing from everyday politics, which many painters did. Daoist ideas of immortality can also be seen in works of the Han dynasty which portray immortals and strange creatures flying among heavenly clouds. The use of materials such as realgar and cinnabar or copies of them in works of art reflects the Daoist pre-occupation with finding elixirs of immortality. Paradoxically, taking some of these potentially poisonous substances led to the deaths of more than one Chinese emperor, including Qin Shihuangdi. Sculptures portraying Daoist figures such as the Eight Immortals or Star Gods became popular in the Ming and Qing dynasties.

Confucian temples had sculptures of gods based on the official order in the world below, such as the god of literature or the god of war. Most towns would have a Confucian temple to its own town gods. Confucian paintings included ancestor portraits, which would be hung in houses at the family altar to the

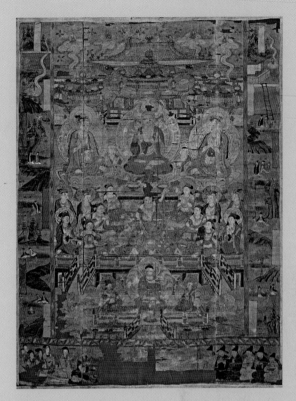

Paradise of Sakyamuni, ink and colours on silk. Tang dynasty, early 9th century. This painting, from cave 17 at Dunhuang, depicts the Paradise of the historical Buddha.

ancestors. The emperor also held Confucian ceremonies at the Temple of Heaven and other altars. Here he, as the Son of Heaven and therefore an intermediary between heaven and the people, would use Confucian ritual objects and music to pray to heaven to grant good harvests and other benefits to the people.

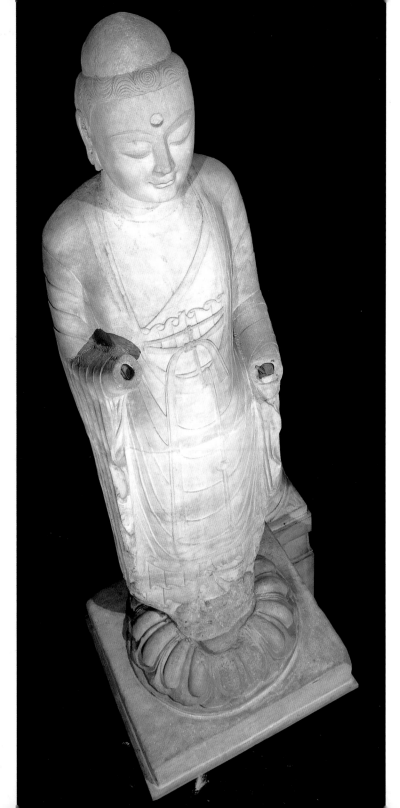

Amitabha Buddha,
micaceous white marble. Sui dynasty,
5th year of Kaihuang (AD 585).
Dedicated at the Chongguang temple in Hebei province, this monumental figure of Amitabha was originally flanked by a smaller standing Bodhisattva, now in the Tokyo National Museum.

The hands of the figure, now missing, were fixed into the arm sockets with wooden dowels, still visible. The right hand would have been raised, palm outwards, in a gesture of reassurance, with the left lowered in liberality. The carving is crisply executed, with sharp pleats in the robe. Sculptural styles which display clinging drapery and anatomically credible bodies first appeared in China in the early 6th century.

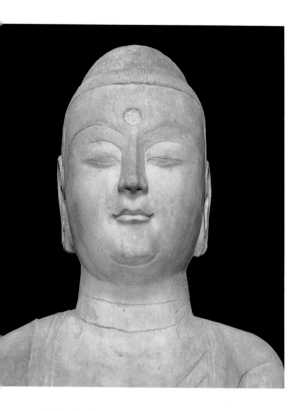

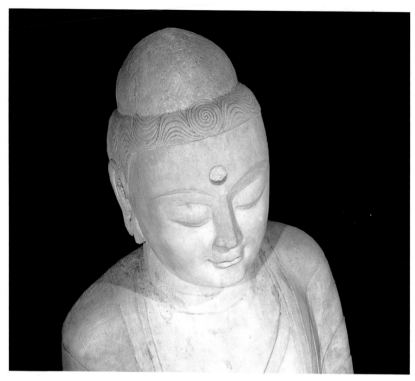

Amitabha is the Buddha who rules over the Western Paradise. Amitabha is a Sanskrit word, literally meaning boundless light. When the Buddha became enlightened he achieved nirvana, having eliminated the causes of rebirth and achieved a state of serenity which is reflected in this face.

Some of the special characteristics of a Buddha are this cranial protuberance, elongated earlobes and a mark in the centre of his forehead. It is thought that the devout who believe in Amitabha and repeatedly chant his name can be reborn after death in his paradise. Amitabha is one of the most popular Buddhas in China.

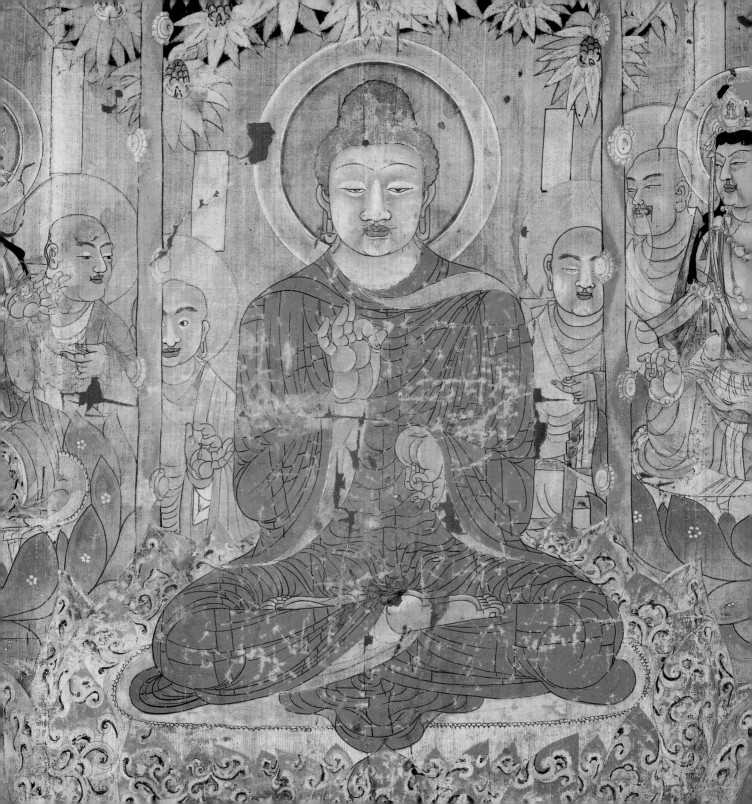

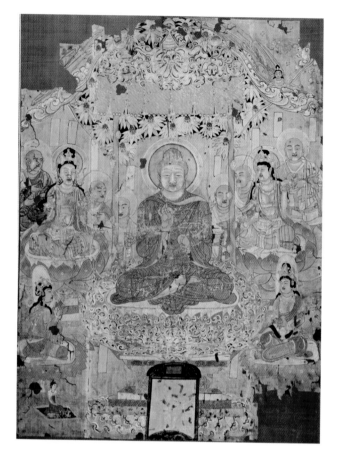

The Buddha Preaching the Law, ink and colours on silk, from cave 17 at Dunhuang. Tang dynasty (early 8th century AD).
This painting shows the Buddha preaching beneath an elaborate canopy. He is seated under the *bodhi* tree where, as Sakyamuni, the historical Buddha, he was sitting when he attained enlightenment. He is accompanied by four seated Bodhisattvas and six monk disciples. At the bottom of the painting on the left is the seated figure of a female donor and on the right is part of the headdress of a male donor, along with a few wisps of smoke from what must have been a hand-held censer.

The neat hair and high-waisted dress of the female donor are similar to wall paintings of court ladies in imperial tombs of the early 8th century. The details of the costumes of both male and female donors of such Buddhist paintings are very important in helping to date these works. Very often the vertical cartouches alongside the bottoms of the paintings were intended to be filled with the names of the donors, but here it is left blank.

Paradise of Sakyamuni, with illustrations of episodes from the *Baoen* sutra (requiting blessings), ink and colours on silk, from cave 17 at Dunhuang. Tang dynasty (early 9th century AD**).**

This painting depicts the Paradise of the historical Buddha Sakyamuni, with jataka scenes at the sides illustrating the story of the Buddha, an Indian prince in his secular life. Sakyamuni is shown with both hands in the gesture of discussion, seated between two Bodhisattvas on a platform with a dancer below and groups of musicians on either side. The donors are depicted below, with the women on the left and the males on the right. Both their style of dress and the composition of the Paradise scene are simple and uncluttered, suggesting an early 9th-century date for the painting.

The *jataka* scenes filling the vertical side borders of the painting illustrate various episodes from the *Baoen* jing, the sutra of requiting blessings, which describes one of the Sakyamuni Buddha's previous incarnations. These landscape scenes are among the earliest surviving landscape paintings in China. The vertical series on the right shows the future Buddha's royal family fleeing after the revolt of a treacherous minister. When their provisions run out the boy offers his flesh to his parents and is eventually left by the roadside with only one piece of flesh left. Then, in the scene above, the god Indra appears in the form of a lion and begs the prince for food. He offers his last piece of flesh, but Indra returns to his true shape and restores the future Buddha to wholeness.

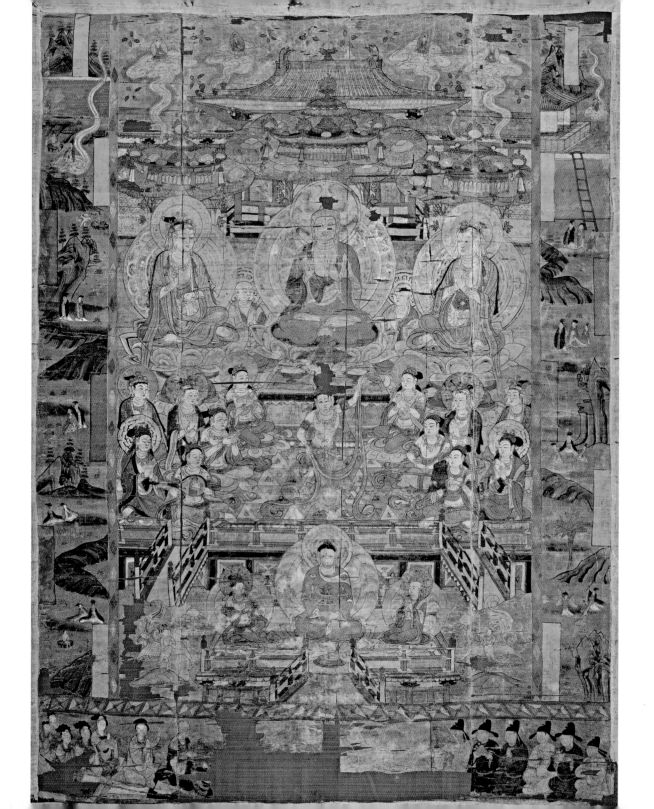

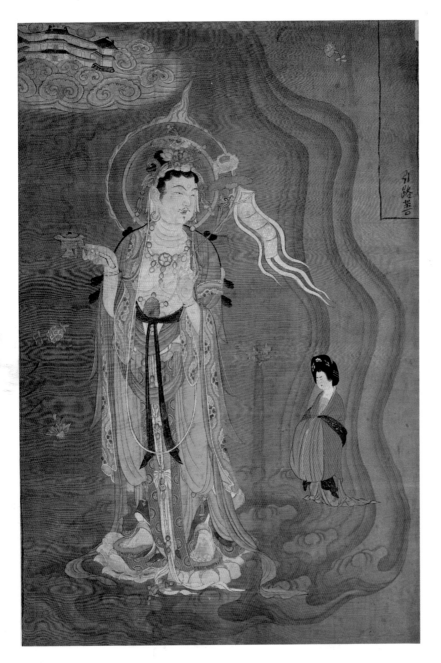

**Bodhisattva as Guide of Souls,
ink and colours on silk, from cave 17,
Dunhuang, Tang dynasty (late 9th century AD).**
This painting has a title, *Yinlu pu* (Bodhisattva
Guide of Souls), and shows a Bodhisattva,
probably Avalokitesvara, leading a finely dressed
female figure to the palaces of Paradise, depicted
in the clouds in the top left corner of the painting.
The Bodhisattva carries a hand-censer in his right
hand, and in his left is a lotus flower from which
hangs a white banner with streamers.

The small figure following Avalokitesvara is an
aristocratic lady wearing the dress and hairstyle
typical of the late 9th century and commonly
depicted on the so-called ceramic Tang dynasty
'fat' ladies. A certain voluptuousness became
popular in imitation of Yang Guifei, concubine of
the Tang emperor Xuanzong, who ruled from 712
to 756. She was known for being plump and set a
fashion for loose, high-waisted dresses. The
noble ladies of this time wore their hair high on
their heads, piled over lots of false hair, much as
European ladies later did in the 18th century. The
hairstyle was then dressed with many decorative
hairpins made of gold, silver and jade.

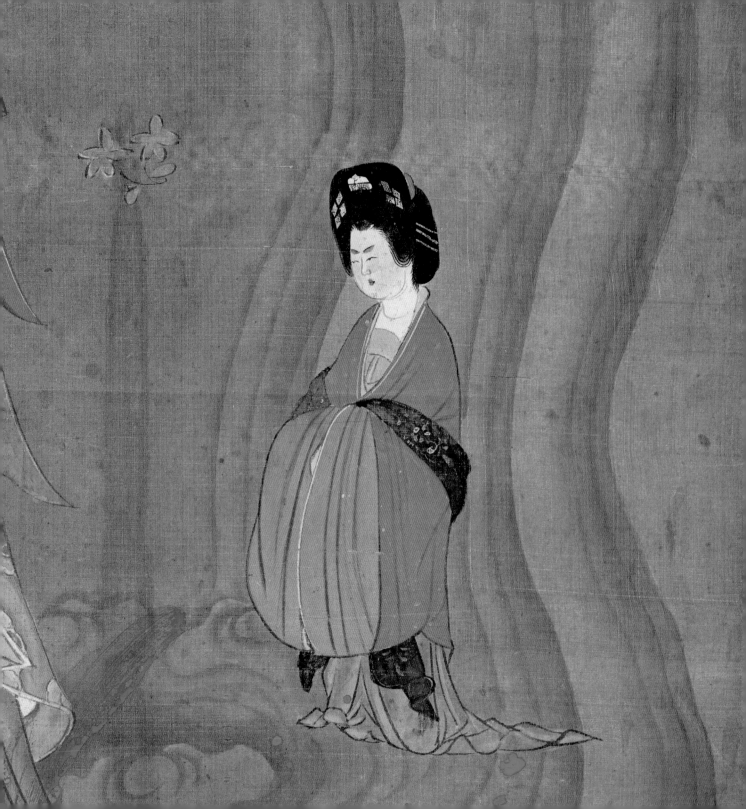

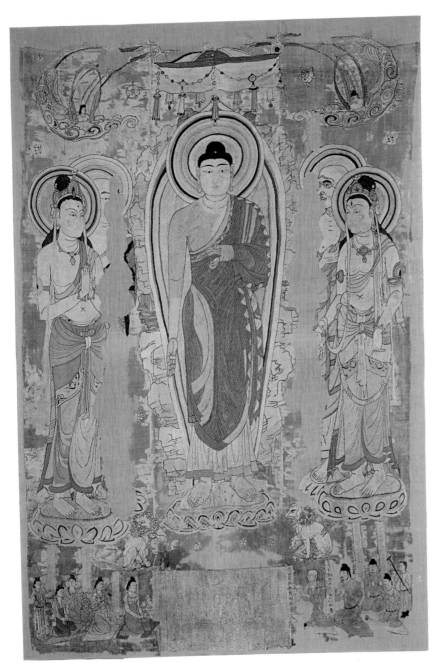

Sakyamuni preaching on the Vulture Peak, silk embroidery on hemp cloth faced with silk, from cave 17 at Dunhuang. Tang dynasty (8th century AD).

This magnificent embroidery is one of the largest Chinese examples known, and its theme and composition compare very closely with the big paradise paintings from Dunhuang. The subject is Sakyamuni preaching the Lotus sutra on the Vulture Peak, which is represented by the rocks surrounding the Buddha. At the top are two *apsarasas* flanking a jewelled canopy and at the bottom are two groups of donor figures and a central inscription panel. Two Boddhisattvas and two disciples accompany the Buddha. The panel was made from three widths of hemp cloth entirely covered with thin, closely woven silk. Large areas of the thin silk beneath the embroidery have worn away, leaving the hemp backing visible.

The embroidery is mostly made up of satin stitch which follows the muscles of the body but the hand is in chain stitch to emphasize its coming forward and to differentiate it from the robe. The pigments used to dye the silk are still very vibrant; dyes were derived from animals, plants and minerals, including indigo. The outline of the design was first drawn in ink onto the silk. The main contours were worked with split stitching of brown or dark blue silk. The areas enclosed by the outlines were then filled in using closely packed unplied floss silk.

Satin stitch is an embroidery technique in which
stitches are arranged neatly and regularly in flat
rows so that no space is left between them,
which gives a gleaming, satin-like surface. It was
often used for embroideries trying to imitate
paintings and was employed on double-faced
embroideries as the basic stitch.

This is one of a pair of diminutive but fierce lions
guarding the Buddha. There are no lions in China,
so the artist could not have drawn from life, but
they were well known in the Near East as symbols
of power and authority and were therefore
adopted as symbols of religious might. From the
3rd century AD lions are used in a Buddhist
context, and Buddhist figures carved in the great
cave-temples of northern China were often
seated on thrones with a lion at either side. From
this custom derived the small guardian lions that
accompanied figures of the Buddha, as here.

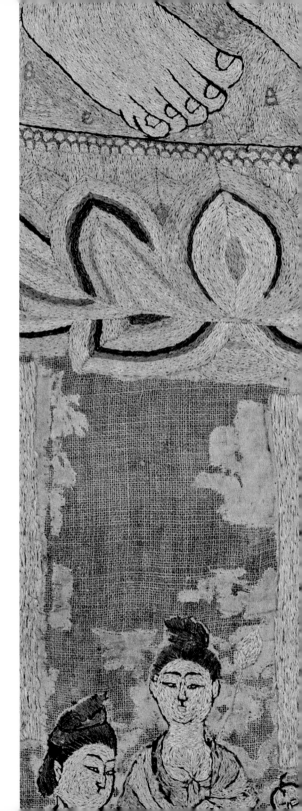

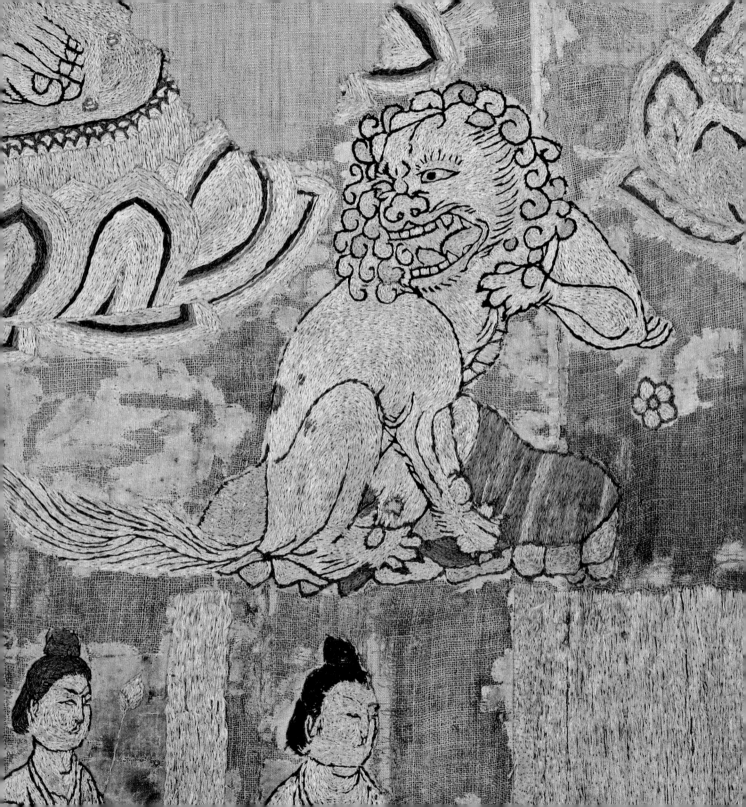

Luohan, stoneware Buddhist figure.
Liao dynasty (907–1125).

Luohans were disciples of the Buddha who had magical powers and could stay alive indefinitely to preserve the Buddha's teachings. In China they were often shown in groups of sixteen or eighteen, with sets of Luohan figures placed along the side walls of a temple's entrance or in groups of pairs on either side of the main Buddha figure. The stern but serene face gives the impression of an individual while at the same time suggesting a commanding religious belief, thereby promoting the idea that all humanity might aspire to the spiritual understanding represented by the Luohan.

The figure is glazed in the *sancai* (three-colour) lead palette characteristic of the Tang dynasty. Following the gently curving surface of the body, a network of vertical and horizontal bands denote the patchwork characteristic of a monk's mantle which was worn as a sign of humility. Monks generally owned only two possessions: their patchwork robe and a begging bowl.

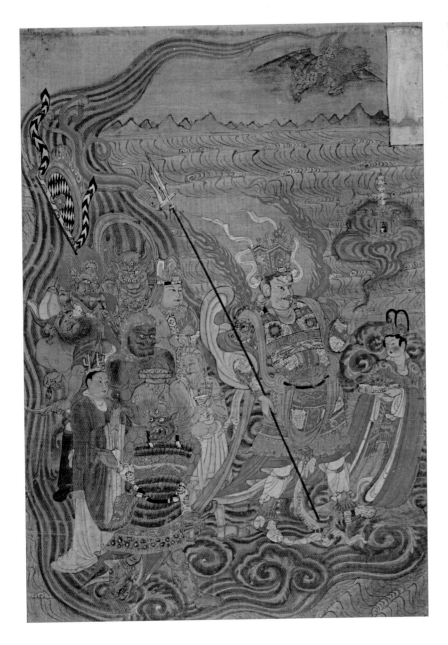

Vaisravana riding across the waters, ink and colours on silk, from cave 17 at Dunhuang. Five Dynasties (mid 10th century AD).

This is considered one of the finest paintings from the Buddhist hoard found in cave 17 at Dunhuang by Sir Marc Aurel Stein in 1907. It depicts Vaisravana, the Guardian King of the North, one of the four kings of the points of the compass, who are usually accompanied by large forces of supernatural warriors. They are important figures in the Buddhist pantheon, acting as protectors of the Law and fighting against the forces of evil. Here the figure at the far left of the group, an archer, is preparing to shoot down the winged thunder-monster flying in the sky above.

Vaisravana is shown crossing the sea with his retinue. In his right hand he carries a golden halberd and in his left a purple cloud supporting a stupa, inside which there appears to be a seated Buddha. In front of him his sister Sri Devi, Goddess of Material Blessings, holds a shallow golden dish of flowers. Behind him is the rishi Vasu, portrayed as a white-haired old man. A stout figure in a green robe stands behind Vasu holding a flaming pearl – this may be one of Vaisravana's five sons.

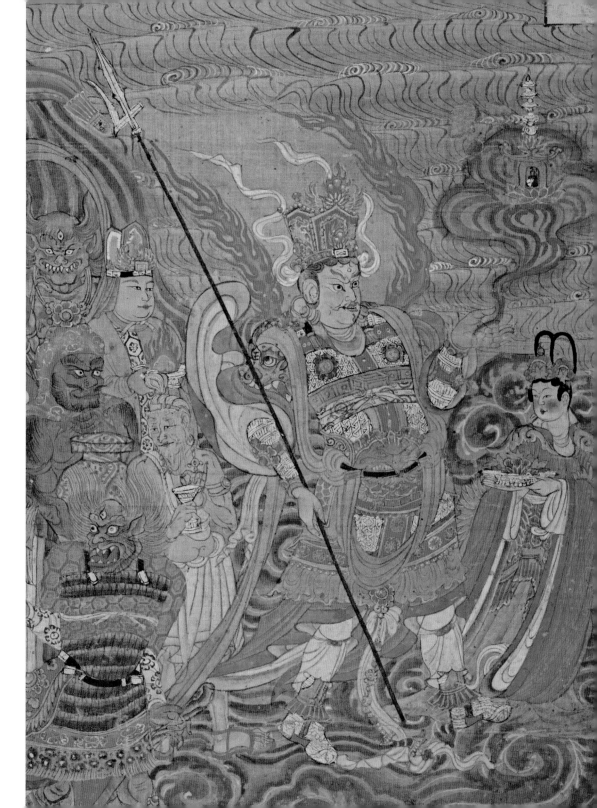

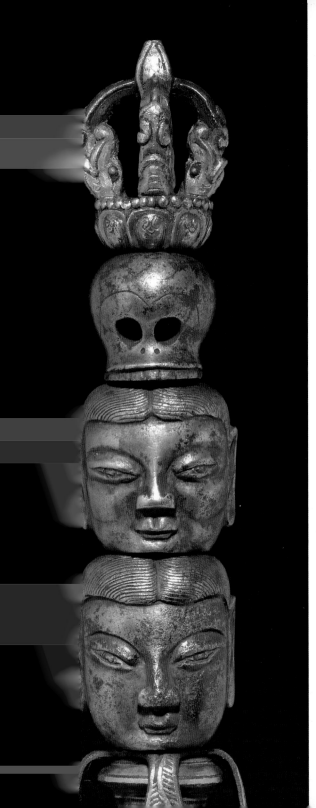

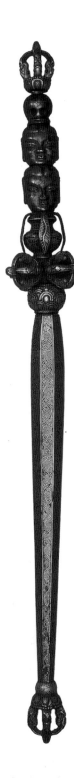

**Khatvanga, iron with gold and silver inlay.
Ming dynasty, Yongle mark and period (1403–24).**

This is a ritual trident or sceptre symbolizing the possession by its bearer of the infinite treasure of the wisdom of the Buddha and also the Thought of Enlightenment ('Bodhicitta'). Khatvangas are composed of images of a severed head, a decomposing head, a skull and the vase of life. We know this particular sceptre was imperially commissioned because it has the emperor's reign mark inscribed around the lowest knop. Buddhist adepts, such as the Indian teachers known as the *siddhas*, are often depicted carrying such staffs.

The gold and silver inlay in the iron body of the sceptre is very skilfully worked. The stem is intertwined with finely inlaid silver and gold, lotus, chrysanthemum and peony flowers, overhung by four slender leaves. This type of silver inlay is associated with the eastern Tibetan town of Dergé. The prongs of the half-*vajras* at both ends and of the crossed *vajras* at the centre issue from animal masks and are suspended on a lotus flower. The *vajra* or pronged thunderbolt is emblematic of the unbreakable nature of absolute knowledge.

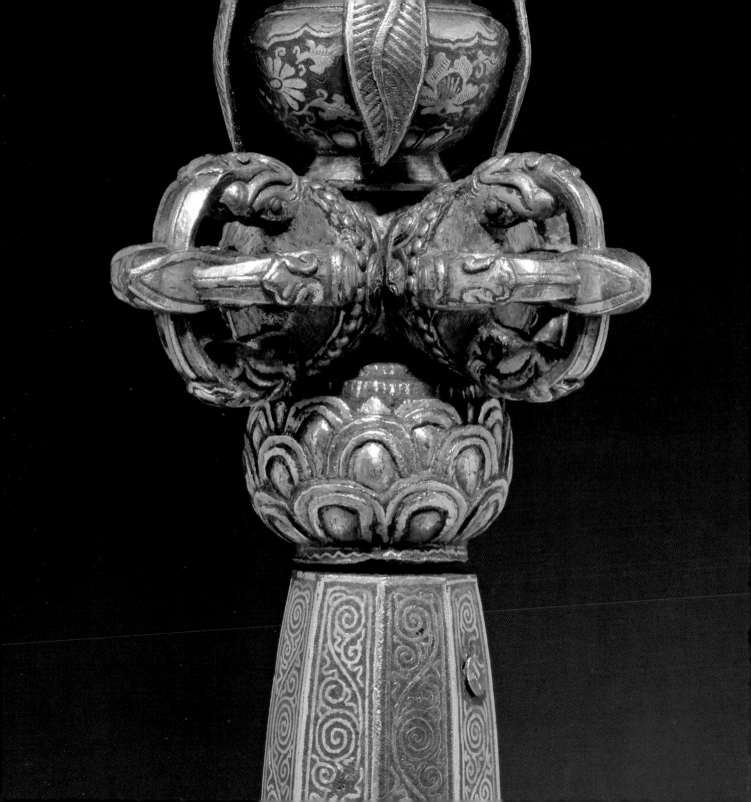

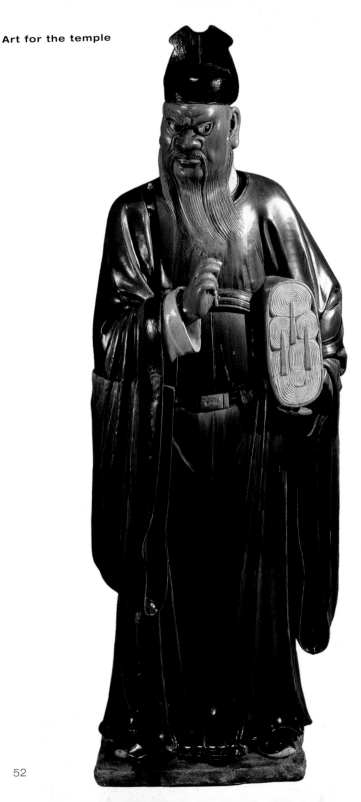

Temple figure of an assistant to the Judge of Hell, ceramic decorated in polychrome enamel with cold-painted details. Ming dynasty (*c*.1522–1620).
This large-scale ceramic sculpture (over 135 cm tall) is in the form of an angry frowning male official, dressed in the aubergine robes of a scholar-mandarin. His black gauze hat, typical of a style worn by literate men in the Ming era, has a domed crown and is high at the back, forming two peaks. Beneath his left arm he holds a large register of several volumes of scrolls, and the fingers of his right hand are poised to hold a brush-pen. The documents may be rolls of names of men and women who must appear before the Judge of Hell to account for their wicked deeds. There were thought to be ten judges or kings presiding over the Chinese Buddhist 'hell', which was conceived as an administrative centre for the underworld and resembled a courtroom. The assistants made their reckoning of a person's life before the Judge of Hell made the final judgement.

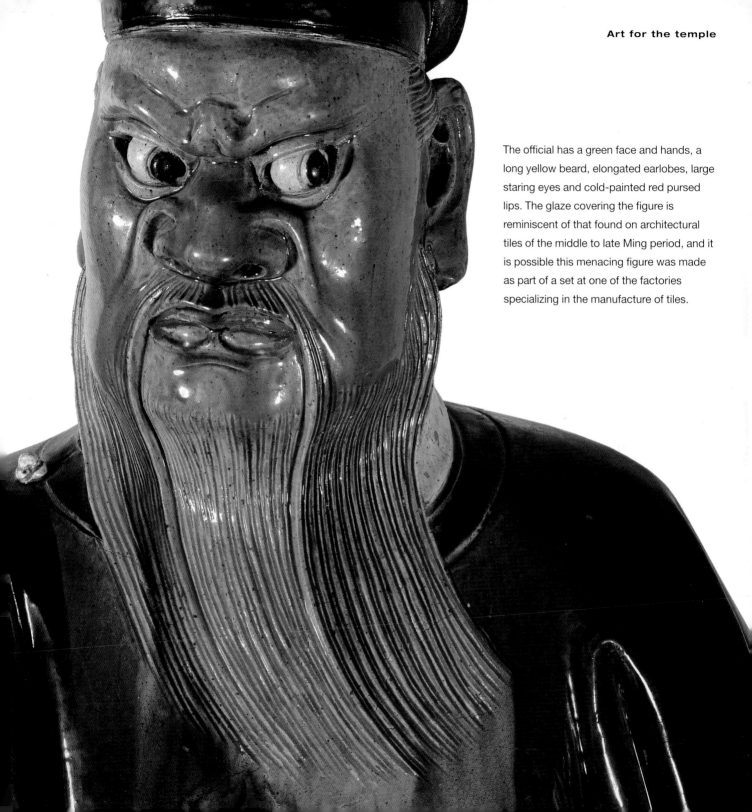

The official has a green face and hands, a long yellow beard, elongated earlobes, large staring eyes and cold-painted red pursed lips. The glaze covering the figure is reminiscent of that found on architectural tiles of the middle to late Ming period, and it is possible this menacing figure was made as part of a set at one of the factories specializing in the manufacture of tiles.

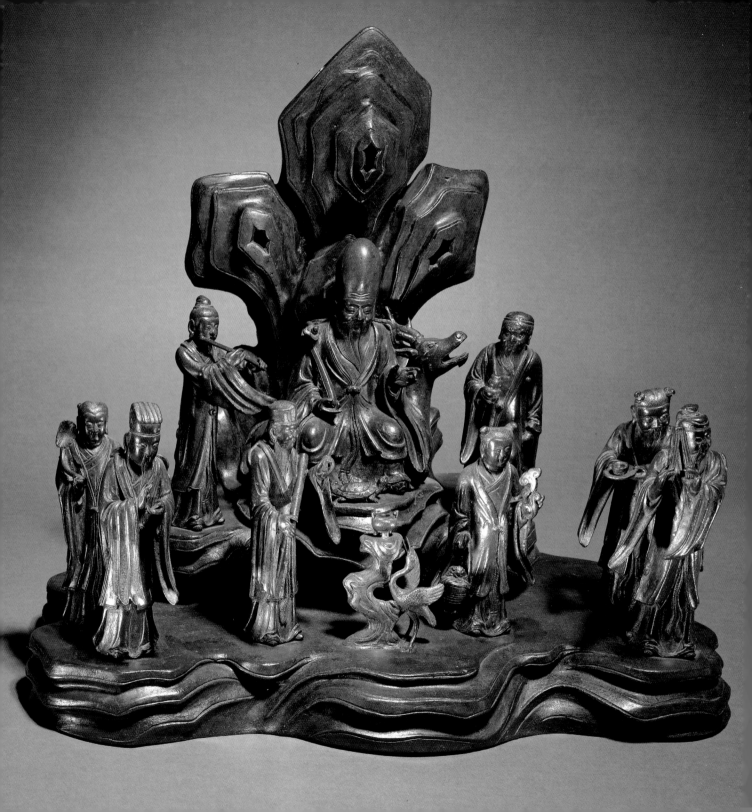

Bronze group of figures.

Qing dynasty (17th century AD).

This group of figures on a mountain includes Shou Xing, the god of Longevity, in the middle, surrounded by the Eight Daoist Immortals. Shou Xing is identifiable by his elongated cranium. The eight immortals form a special group of 'saints' or gods. They are often depicted together, though they are also shown individually. Membership of this select group has varied over the centuries and each immortal has his own special attribute. The mountainous setting of this bronze group symbolizes the mountains of immortality, where it was believed that one of the paradises existed.

On the extreme right is Cao Guojiu, who was supposedly originally a Song dynasty (960–1279) official and is depicted wearing a court head-dress and official robes. His emblem is a pair of castanets which he holds in his hands. These are said to be derived from the court tablet which would have authorized officials access to the royal palace. He is a patron of the theatrical profession.

Lan Caihe, at the front on the right, is identified by her basket. She is sometimes regarded as a woman with only one shoe, who goes through the streets begging. She sings a doggerel verse denouncing this fleeting life and its delusive pleasures. Her emblem is the flower-basket she carries and she is the patron saint of florists.

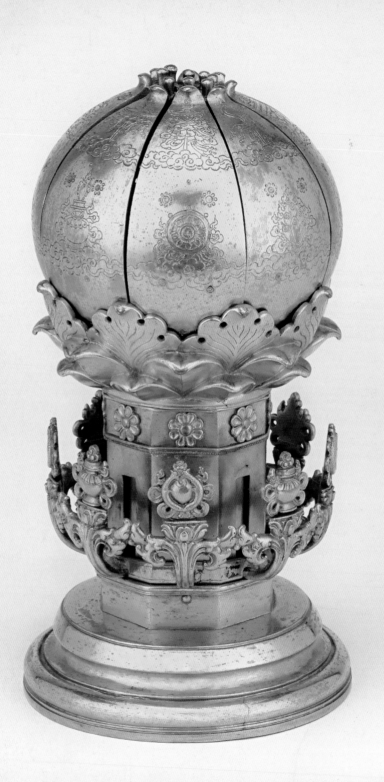

Gilt bronze _mandala_.

Qing dynasty (17th–18th century).

This is a Chinese Tibetan version of an eastern Indian bronze lotus _mandala_, here cast as an articulated pomegranate. At the centre is Chakrasamvara, the esoteric or hidden form of the Buddha. He is shown embracing his 'wisdom partner' – the female represents wisdom and the male compassion.

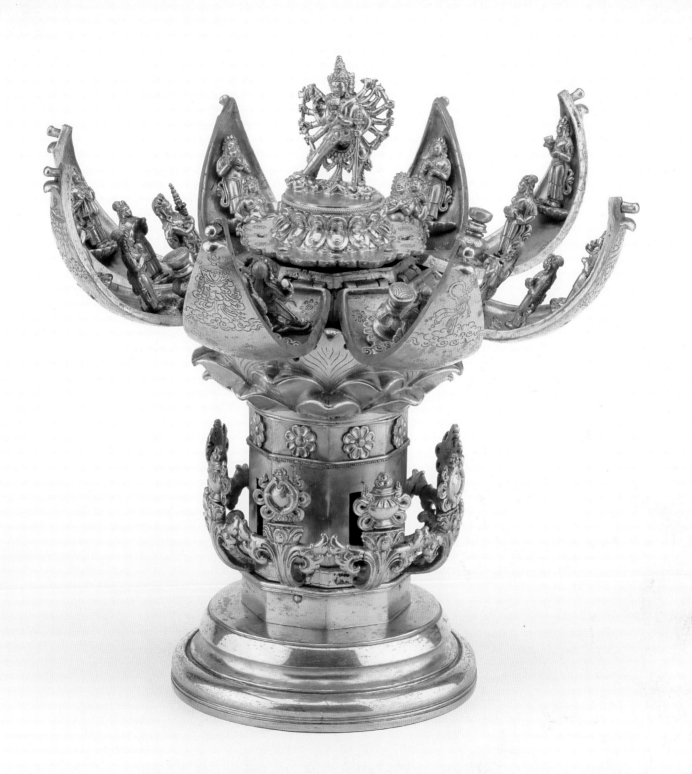

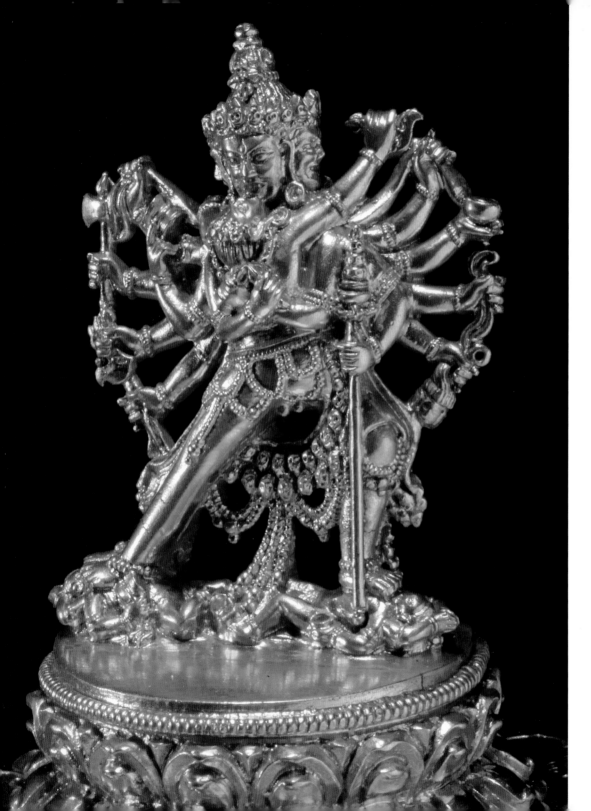

The multi-armed
figure is a
manifestation of
Buddhahood. A
feature of Tantric
Buddhism, this form
is thought to have
appeared at Mt Kailas
in the western
Himalayas.

Twenty lesser divinities surround the two central figures, two or three on each petal, before circular drums or altars. The petals themselves are incised outside with deities and Buddhist symbols including a horse, elephant, wheel, censer, ewer, staff, parasols, ribbon, canopies and jewels. It is an outstanding example of the work executed at Beijing for the Tibetan temple established in the Kangxi period (1662–1722).

4

Art for the court

Court art is clearly distinguished by its supreme quality, as all works of art or utensils or clothes produced for the emperor would have to be the best available, both in terms of craftsmanship and materials. It was also made in large quantities due to the grand scale of Chinese imperial palaces, where hundreds of concubines, eunuchs, attendants and of course the numerous wives and children of the emperor would all live. The Kangxi emperor (1662–1722), for example, had 56 children, 123 grandsons and 30 consorts of varying ranks, as well as concubines.

The epitome of court art was produced for the Forbidden City, the main residence of Chinese emperors from the 13th to the 20th centuries. Architecture, furniture, paintings, porcelains, carvings of jade and precious stones and woods, lacquer wares and sumptuous robes all reflected the emperor's position as the Son of Heaven, at the centre of the universe. Dragon and phoenix motifs were reserved for the emperor and empress respectively, while many objects made for their use bore symbols of auspiciousness, often based on puns on the pronunciation of Chinese characters: for example, bats symbolized prosperity and fish symbolized plenty. Five-clawed dragons were exclusive to the emperor: sometimes the imperial origins of a piece of carved lacquer can be detected by signs of the removal of the fifth claw when the object left the palace.

Objects made for the emperor's use are usually marked in some way. Reign marks painted on the base of porcelains or lacquer wares not only tell the date of manufacture of a piece, but also often bear additional inscriptions such as 'made for the emperor'. Objects and paintings collected by emperors are also marked, usually by stamping an imperial seal on a painting or by writing an inscription on a ceramic. The Qianlong emperor (1736–95) was the greatest collector of all the Chinese emperors. He loved to write or have carved inscriptions in his own calligraphy on ancient works of art, including jades and Song dynasty porcelains. He also wrote on ancient paintings and had numerous

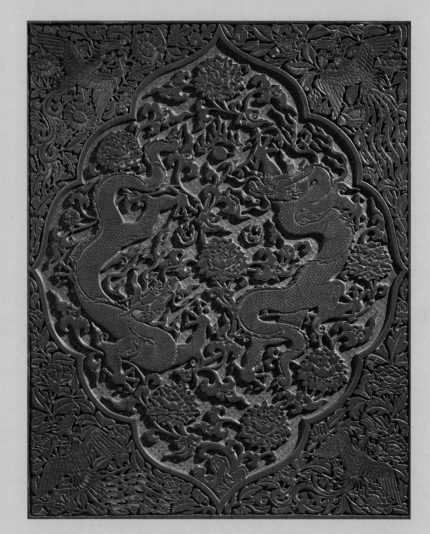

**Red lacquer panel with detail of two
five-clawed dragons, symbol of the emperor.
Ming dynasty (early 15th century).**

seals stamped on them as marks of imperial
ownership. Emperors regarded their
possession of large collections of valued
antiquities and paintings as a legitimization of
their right to rule – the 'mandate of heaven'.

Individual emperors' tastes are also
reflected in the works produced for them. The
Yongzheng emperor (1723–35), for example,
had rather subtle and elegant taste, epitomized
by the beautiful *famille rose* porcelains
developed during his reign. The emperor
Jiajing (1522–66) was a Daoist, and this is
reflected in the many Daoist motifs – such as
cranes, Daoist Immortals and the Daoist God
of Longevity, Shou Lao – which appear on
works produced for him.

Numerous Western museums and
collections include examples of Chinese court
art. Many were acquired during the 15-year
period after the end of the Qing dynasty and
before the Forbidden City was opened to the
public in 1925, during which parts of the
imperial collection were sold or given away by
the last emperor and his eunuchs.

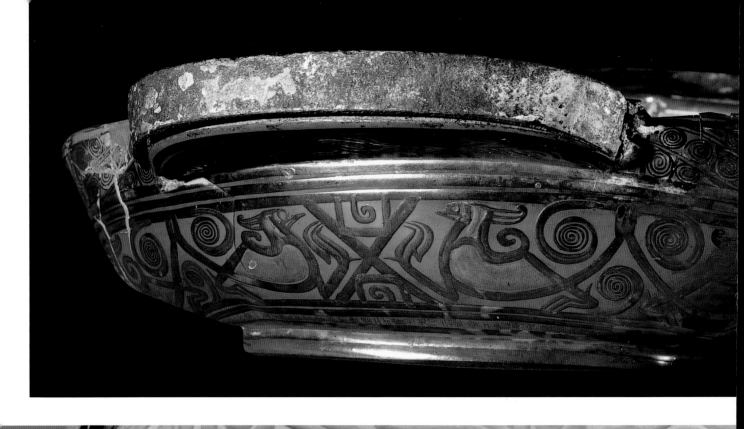

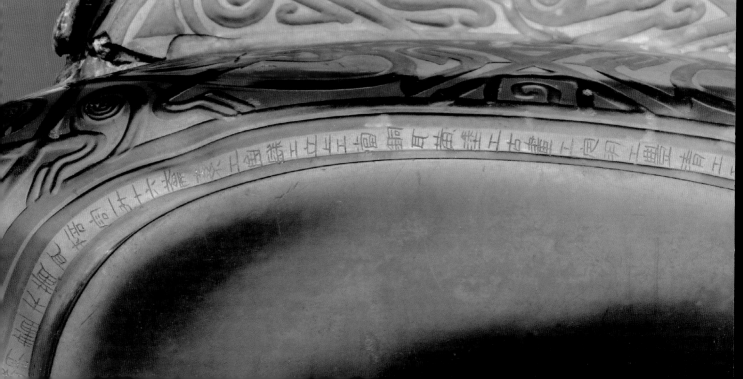

Lacquer cup dated AD **4.**

Han Dynasty (206 BC–AD **220).**

This cup was found in Pyongyang, North Korea (part of the newly expanded Chinese territory of the time) and may have been given by the emperor to an official in lieu of salary, as was then common. It is painted with angular bird motifs resembling patterns on contemporary bronzes. However, lacquer was much more prized and expensive than bronze, and records of the time relate that you could buy ten bronze cups for the price of one in lacquer.

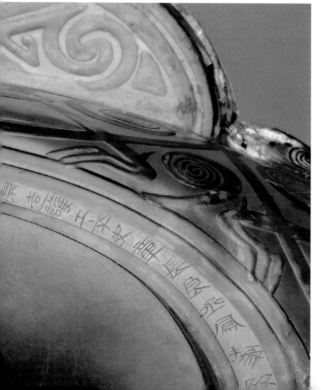

The long inscription of 65 characters around the base of this cup gives the names of the six craftsmen who were involved in every process of manufacturing it, from the wooden core to the placing of the bronze 'ears' as handles, and the seven men who acted as product inspectors at every stage of its production. The inscription tells us which emperor it was made for and the year of his reign (the equivalent of AD 4), and that it was made in Sichuan province. This cup is a good example of early mass-production and quality control.

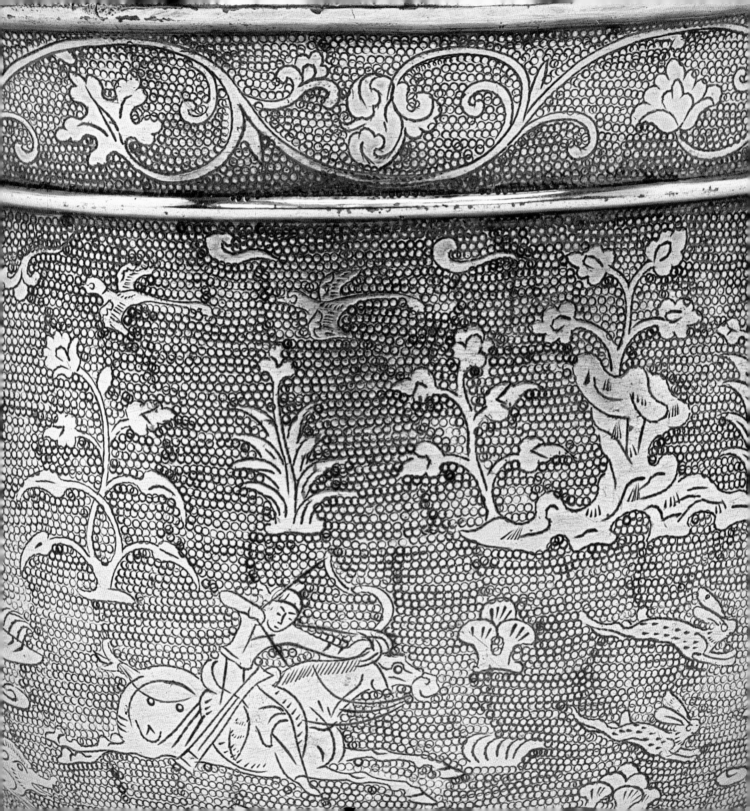

Silver stemcup.

Tang dynasty (8th century).

Jade and bronze were traditionally prized by the Chinese as their most valued materials, whereas gold and silver were not so highly rated. However, gold and silver utensils were gradually introduced to China from Central Asia and lands further west. The idea of using these precious metals for religious objects and later secular use was particularly popular with the non-Chinese Buddhist rulers of north China during the period between the Han and Tang dynasties (220-618), and such usage gradually became widespread among the Chinese elite.

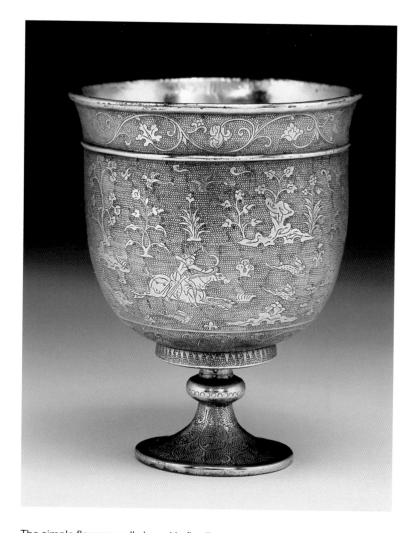

This horseman hunting deer is using a bow and arrow – such scenes were copied from Chinese paintings, lacquer designs and tomb murals. The mounted archer is also often found on Tang dynasty artefacts such as woven and printed silks from Turfan in Central Asia. This huntsman is set against a ring-punched background, amidst a landscape design of trees and flowers. The taut plant scrolls with palmette-like flowers are the Tang version of a motif originally derived from the Near East but already established in the Chinese tradition for some three centuries.

The simple flower scroll chased in fine lines against a plain background would not have been easily visible without some sort of texture to distinguish the smooth petals and leaves from the undecorated surface of the cup. The fine ring-punched background makes this decoration explicit.

Dish of Ru ware.

Song dynasty (late 11th–early 12th century).

This wide bowl is slightly foliated at the rim. Shallow dishes of this shape are usually considered to be brush-washers, an important component of the scholar's desk. Although ceramics were mostly made for mass consumption, a few types were commissioned directly for the emperor. Some literary evidence exists to suggest that the pale duck-egg blue Ru wares were made as imperial wares for a short time, possibly to emulate jade, apparently for the emperor Huizong (1100–1125).

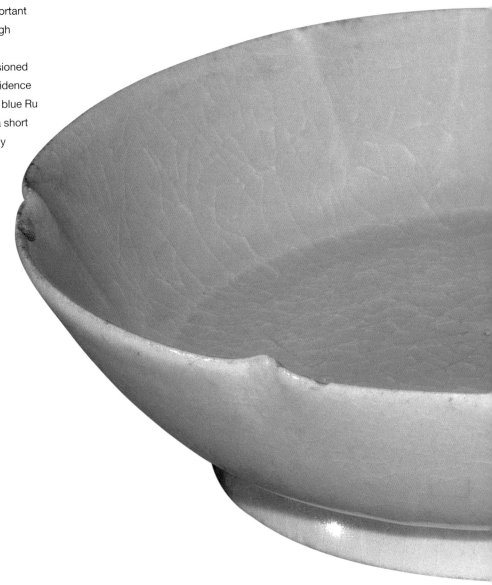

The site of the Ru kiln in Henan province was only discovered in 1986, and today Ru wares are the rarest of all Chinese ceramics. Long regarded as the acme of Song ceramic production, they have been praised for their beauty and rarity by connoisseurs for many centuries.

Flowers, dragons and phoenixes

Flowers are a frequent form of decoration in Chinese art. The flowers of the four seasons are the peony for spring, the lotus for summer, the chrysanthemum for autumn and the bamboo and plum for winter.

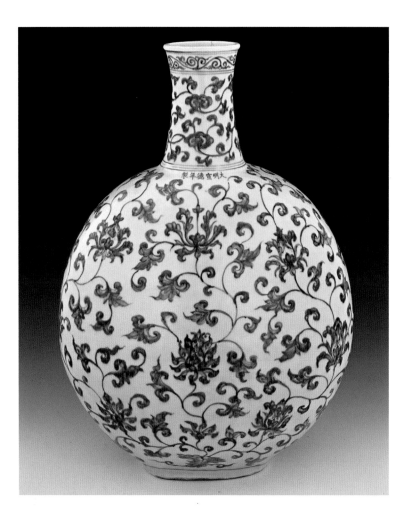

Blue and white porcelain flask.
Ming dynasty, Xuande mark and period (1426–35).

The shape of this porcelain flask probably derived from Near Eastern metalwork or glass. Much of the early underglaze blue and white ware was made for and exported to the Middle East but, during the reigns of Xuande (1426–35) and Chenghua (1465–87), very fine Ming dynasty blue and white wares were produced and became widespread throughout China. The reign mark suggests that these painted wares were by then being used in the palace. There was an imperial porcelain factory at Jingdezhen throughout the Ming and Qing dynasties.

The flask is decorated around the neck with a continuous *lingzhi* scroll and around the body with a continuous stylized lotus scroll, with flowers in full bloom and about to turn to seed. The rim is ornamented with a band of classic scroll.

Cobalt was first imported from Persia and liberally used, particularly at Jingdezhen, which has dominated the ceramic manufacture of China over the last millennium. Later local sources were also found. The cobalt has precipitated out through the glaze, and here and there black patches appear, creating an effect known as 'heaped and piled'.

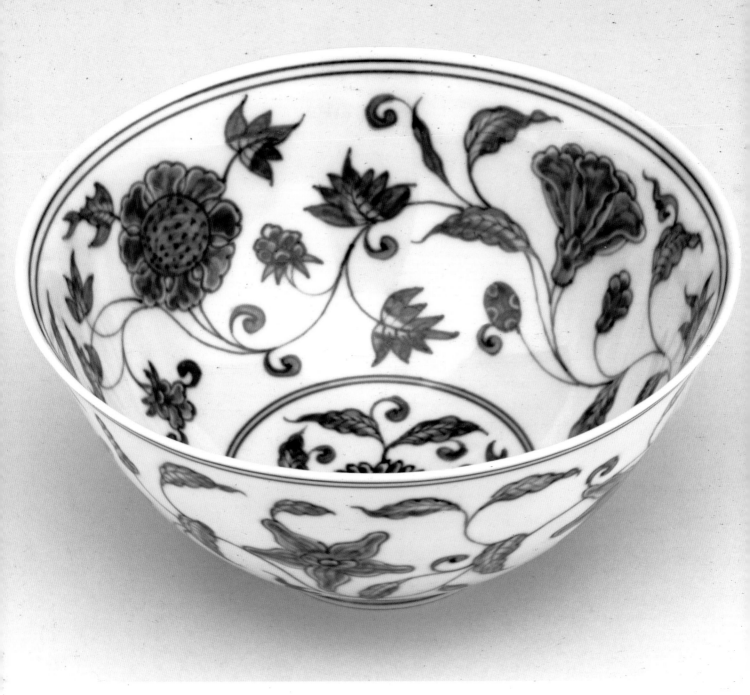

70

Blue and white porcelain palace bowl.
Ming dynasty, Chenghua mark and period
(1465–87).

This porcelain palace bowl bears the Chenghua emperor's reign mark (1465–87) on its base. The thin walls, even glaze and high quality of both the cobalt blue tone and the painting combine to give Chenghua wares their reputation as the finest blue and white porcelains. As the potters became more proficient in producing a purer body, so the painters left more of the surface blank, and the painting appears less dense than in the Yuan and earlier Ming periods.

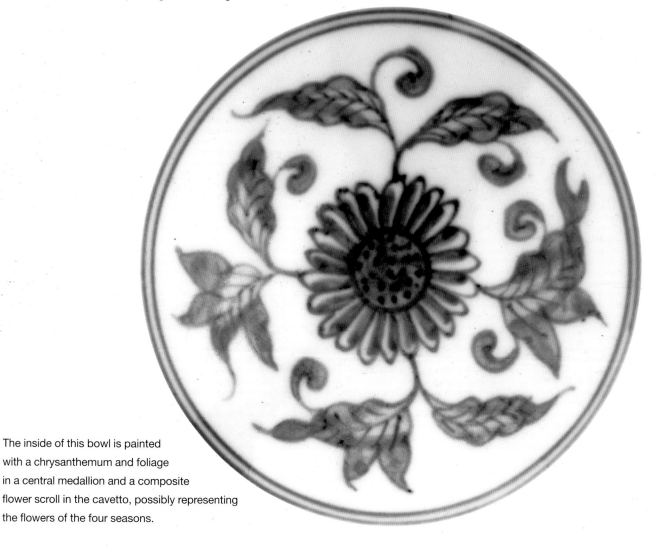

The inside of this bowl is painted with a chrysanthemum and foliage in a central medallion and a composite flower scroll in the cavetto, possibly representing the flowers of the four seasons.

Dragons

The beneficent dragon of the East is a complete contrast to its Western counterpart with its fiery nature and associations with evil. In the East the dragon is associated with life and with fertility because it brings rain. The dragon is first mentioned in Chinese literature in the *Yijing* and took its initial form some time in the Neolithic period. The dragon gradually became an insignia of royalty and dominion and came to represent the emperor, the Son of Heaven.

The emperor's throne was called the dragon throne and his face was referred to as the dragon's countenance. The dragon is also considered a male symbol of vigour and therefore *yang*, as opposed to the female *yin*. It is the fifth creature in the Chinese zodiac and represents the East, the region of sunrise, fertility and spring rains. It is therefore a force for good – dragon dances are a common part of Chinese New Year celebrations.

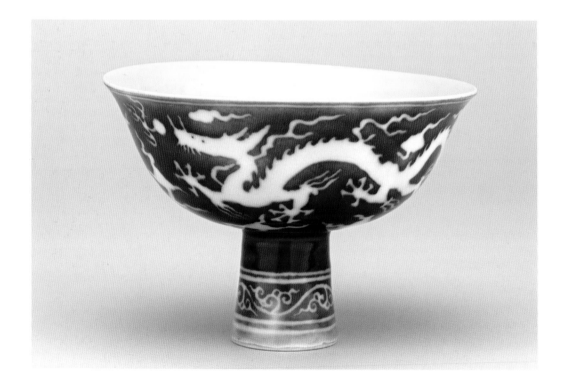

Porcelain stem cup with copper-red glaze.

Ming dynasty, Yongle reign (1403–25)

The Chinese apparently first considered both underglaze red and underglaze blue wares to be suitable only for export to the Near East, for which they were specifically made beginning in the Yuan dynasty (1279–1368). However, from the early part of the succeeding Ming dynasty it appears they were acceptable to the imperial court, and those pieces found at the site of the imperial factory include the first group of porcelains ever to bear the name of the emperor in whose reign they were produced. These either bear the five-clawed dragon symbol of the emperor or the phoenix symbol of the empress.

This stem cup is decorated on the exterior with a red underglaze design of two dragons chasing the flaming pearl, representing thunder, amid clouds reserved in white against the copper-red ground. This design also appears inside the cup, incised in the *anhua* or 'hidden design' technique.

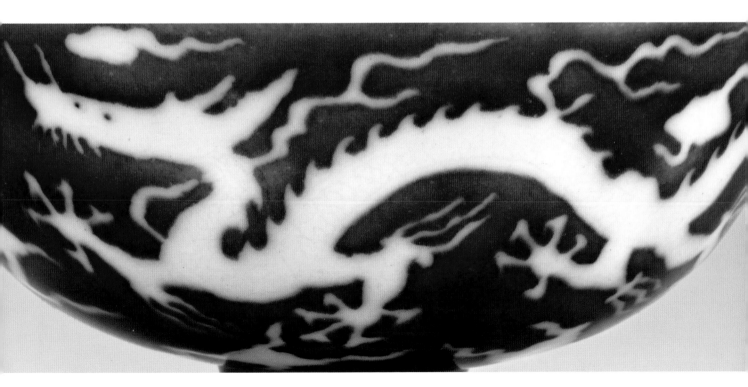

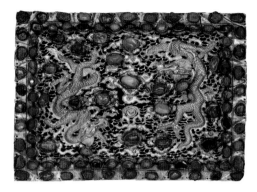

Rank badge made of gold and semi-precious stones.
Ming dynasty (15th century).

From 1652 all civilian and military officials were required to wear rank badges,
displayed on three-quarter-length dark overcoats. These badges were
smaller versions of the textiles decorated with birds and animal designs that
had been applied directly or woven into robes during the Ming dynasty. In the
Ming and Qing dynasties the imperial nobility wore round badges
(representing heaven) decorated with dragons, while civil officials wore
square ones (representing the earth) displaying different types of birds,
according to their rank. Military officials wore square badges displaying
animals, symbolizing courage. Ming emperors and their immediate family
wore badges bearing dragons while the empress wore a phoenix, but in the
Qing dynasty women wore the same badge as their husbands.

This gold garment plaque, one of a pair, can be
regarded as a high-quality version of the cloth rank
badge. It was probably made for imperial use, because
in the Ming dynasty only the emperor could use items
decorated with five-clawed dragons. It is decorated
with two dragons and a flaming pearl among clouds,
worked in relief with chased detail and openwork and
inlaid with semi-precious stones. The plaque is pierced
around the edge for attachment to a robe. Two rows of
inlaid semi-precious stones frame the dragons.

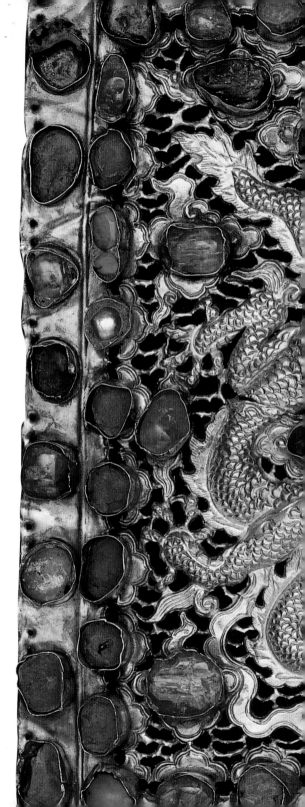

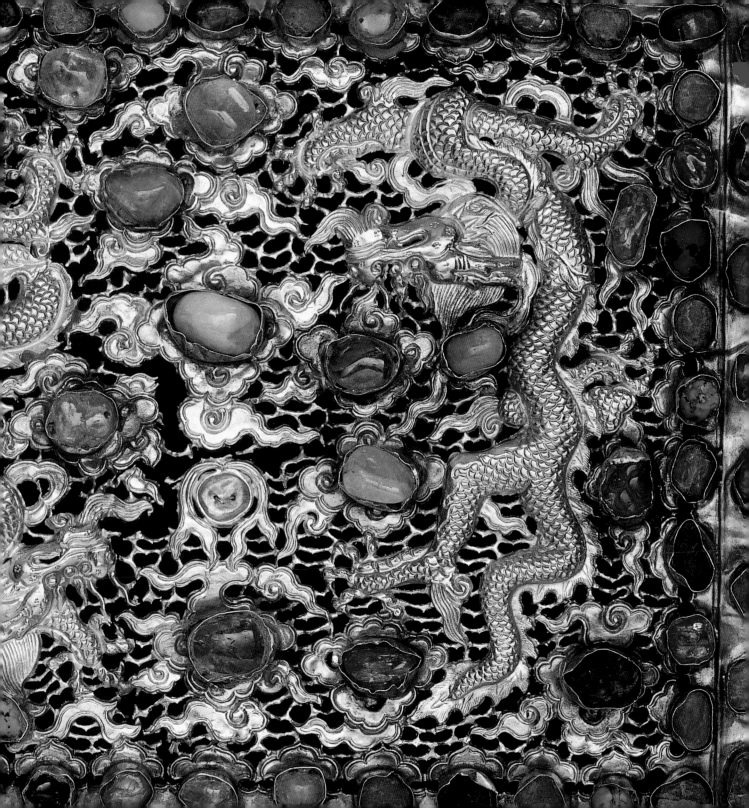

Large cloisonné enamel jar.

Ming dynasty, Xuande mark and period (1426–35).

The Chinese adopted the use of cloisonné from Byzantine artisans and by the 15th century they had perfected the technique. The earliest dated Chinese cloisonné appears in the Xuande period (1426–35), by which time very high-quality imperial pieces were being produced. The inscription on the neck of this large jar shows that it was made under the auspices of the *Yuyongjian*, a division of the Imperial Household. The reign mark in *champlevé* enamel suggests it was used in the imperial palace. The vigorous dragon among clouds parallels the decoration on blue and white porcelain of the period.

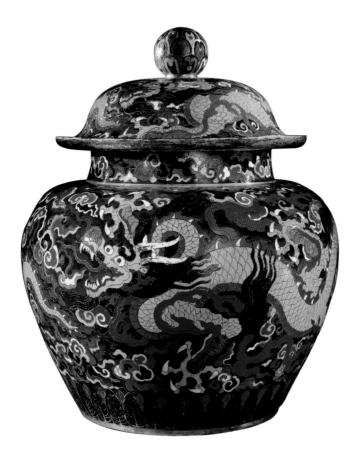

Cloisonné enamel decoration consists of coloured glass paste applied to metal vessels and contained within enclosures made of copper. Various metallic oxides were mixed with the glass paste in order to colour it.

Here the five-clawed imperial dragon with open mouth pursues a pearl in a clouded sky. The domed lid is also decorated with a similar dragon in clouds, with a finial in the shape of a lotus pod enclosed in petals. The base is surrounded by a lappet band.

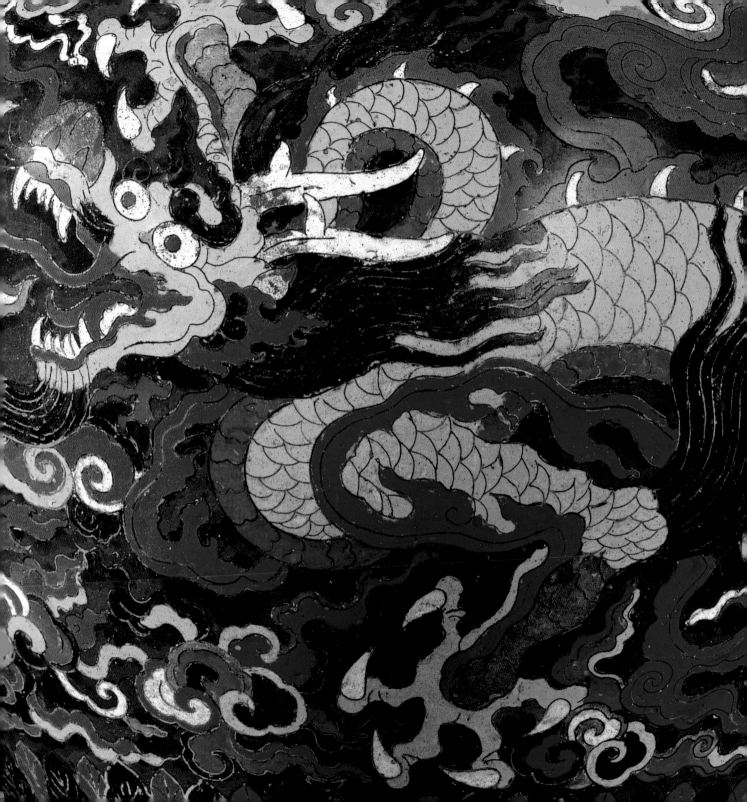

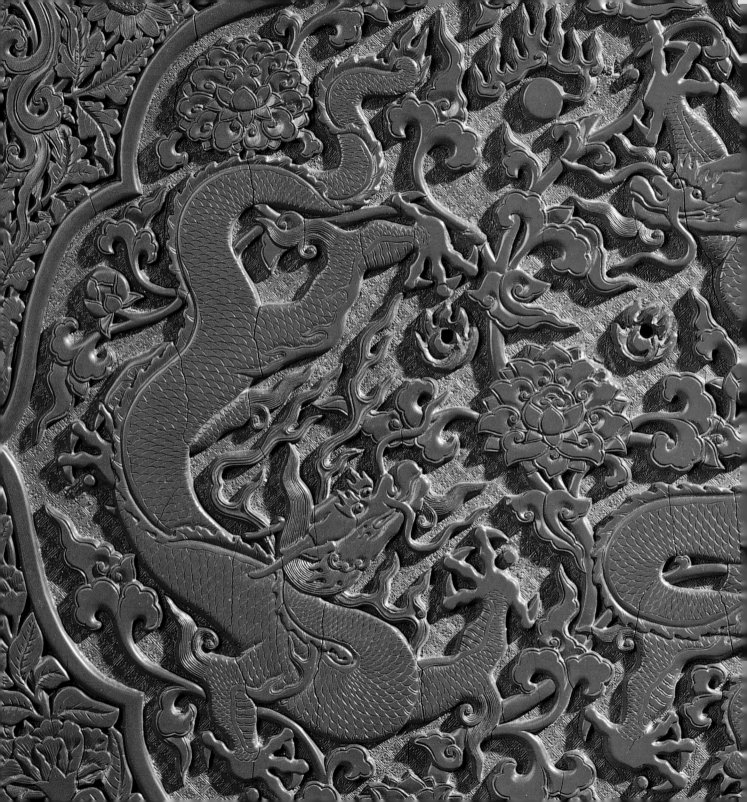

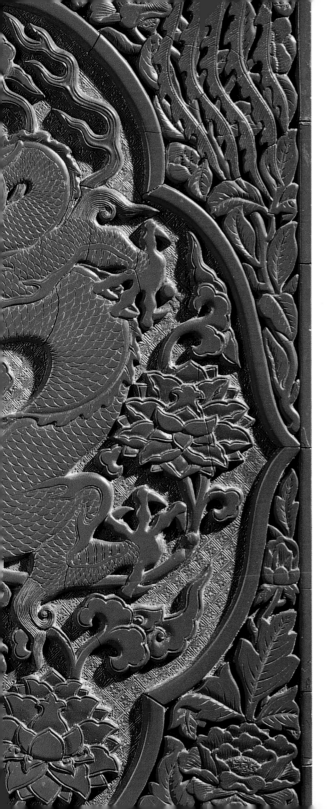

Rectangular panel of red lacquer carved on a yellow ground. Ming dynasty (early 15th century).

In the centre is an ogival panel with two five-clawed dragons, the symbol of the emperor, with a flaming pearl and peony scrolls. One claw on each foot of the dragons has been removed, possibly to disguise imperial provenance as only the emperor was permitted to have dragons with five claws. In the corners are phoenixes, the symbol of the empress, among the flowers of the four seasons. This panel was originally the side of a small cabinet containing drawers.

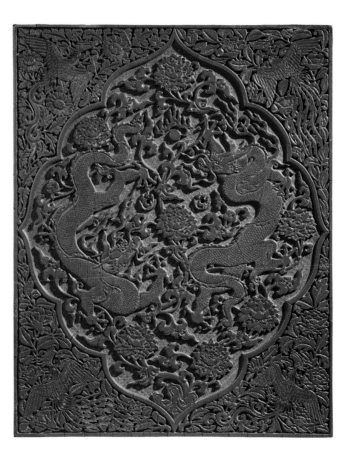

Jade belt plaque.

Ming dynasty (16th–17th century).

Sets of jade belt plaques carved in relief with dragons and flowers were popular in the Ming dynasty. They would have been applied to a textile belt using the small holes around the edges and on the back. By the Ming and Qing periods the predominant ornament for men was the belt. As in earlier periods, belts of particular materials were restricted to specific ranks, and only officials of the first rank could wear jade belts. Lions and dragons were often used as decorative motifs, and such powerful animals would naturally have seemed appropriate on the belts of princes and high-ranking officials.

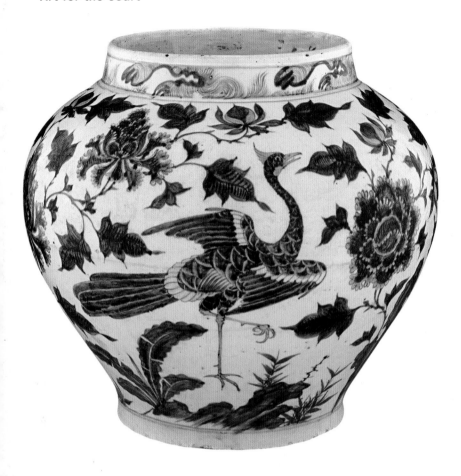

Blue and white porcelain jar.

Yuan dynasty (14th century).

When phoenixes or related bird designs were painted around circular jars such as this one, the organization of the space became a problem. Birds, particularly static non-flying ones, were less sinuous than dragons, so the extra space around them was filled with clouds or flowers.

Here a few long plantain leaves and sprays of bamboo fill out the line of the ground, together with rocks and flowers. This artificial landscape provides a decorative scheme around a peacock and, on the other side of the jar, a peahen.

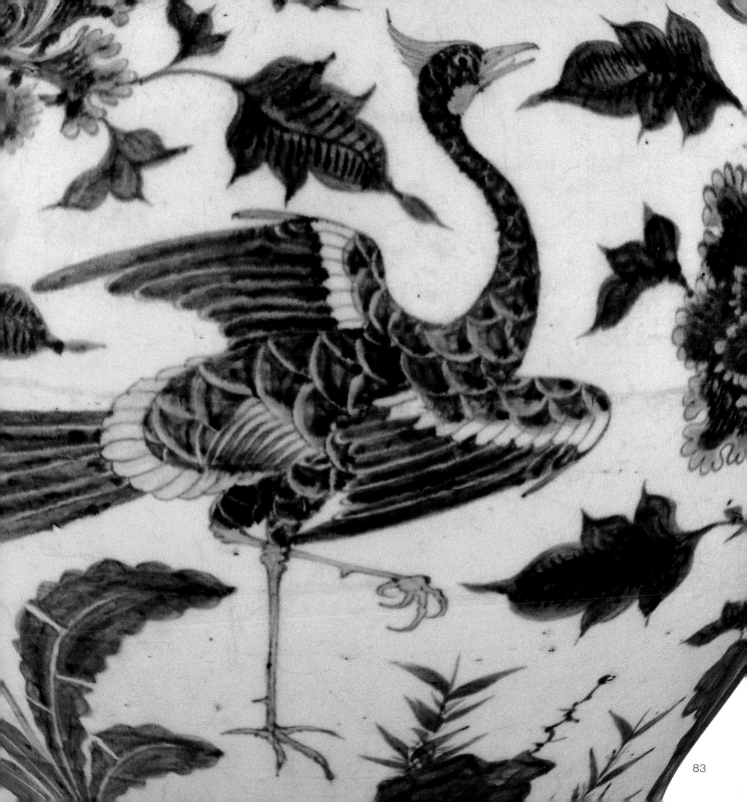

5

Art for the elite

OPPOSITE
Jade brush pot for the scholar's desk, densely carved to produce the effects of the painting or print from which its agricultural scenes were copied. Qing dynasty (18th century).

In antiquity, bronzes and jades were made for the elite and buried in their tombs. In the sumptuary laws, jade was at the top of the hierarchy and its use was restricted to royalty and the elite. Bronzes were often given as gifts or rewards and inscribed to record the occasion and reason for the gift.

Writing has always been the most valued of art forms in China, associated with the educated upper classes. Calligraphy was thought to be able to express the personality and integrity of the writer. The highpoint of Chinese calligraphy traditionally occurred in the 4th century AD with the famous calligrapher Wang Xizhi. All later calligraphers and painters looked back to this golden age and imitated Wang's style. Painting was closely associated with calligraphy and was particularly appreciated by the elite.

The elite were scholar amateurs who painted for pleasure and for self improvement but not for money. Scholarly gentlemen would hold painting and calligraphy parties, where they would play the qin (zither) and compose poetry in the traditional gardens of the area. Motifs on objects associated with scholar's taste include the 'Three Friends' (pine, prunus and bamboo).

Objects used for painting and calligraphy or to adorn the scholar's desk were only for the elite. Brushes and brush rests, inkstones and ink sticks, brush pots and water droppers were all collected with an eye to good taste. Bamboo carving and seal carving were crafts particularly associated with and practised by the scholar gentleman. Seals were of course important, as they were stamped on to paintings to show one's ownership of it. Sometimes a famous painting could have many seals scattered all over it, showing its lineage in terms of the collectors who had owned it.

Since the educated elite in China had a reverence for antiquity, they collected ancient bronzes and jades. Copies were also made from the Song dynasty onwards in archaistic style, which were valued and collected in their own right. Ceramics were never as highly valued by the elite, although some wares, such as Ru ware of the Song dynasty or delicate *famille rose* porcelain of the 18th century were exceptions.

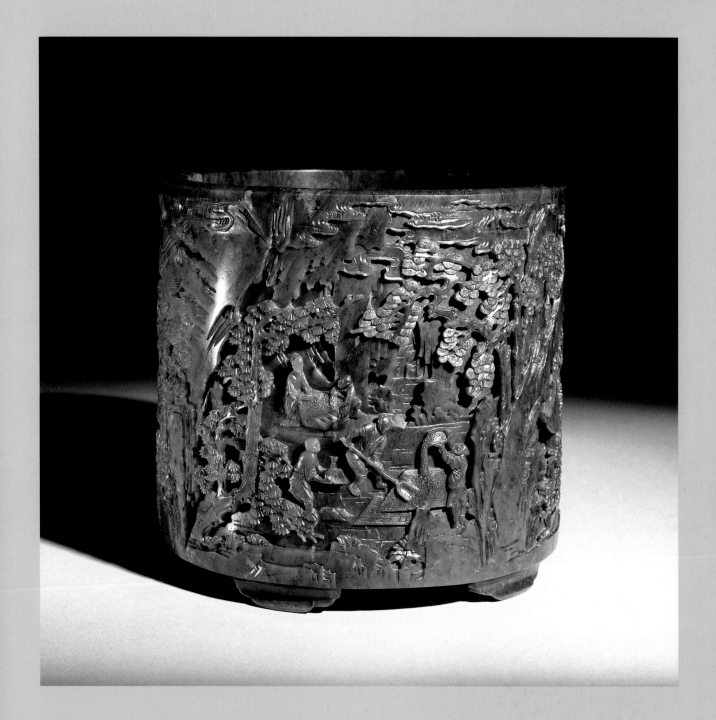

Jade weapon hilt ornament.
Eastern Zhou period (6th–5th century BC).

This rare fitting is in the shape of a slightly tapered cylindrical drum. On the top is a bronze setting holding a domed turquoise cabochon. A hole for attaching a blade hilt or some similar item is drilled up the middle, slightly off centre. A variety of boldly formed fittings were made to embellish weapons. The use of such carefully carved jades, which would have required a large investment of both skill and time, shows how highly their owners must have valued the weapons.

The sides of the cylindrical fitting are divided into three registers by narrow ridges incised with fine striations. Within each register are small tiger or dragon heads in relief, intermingled with abstract scrolls.

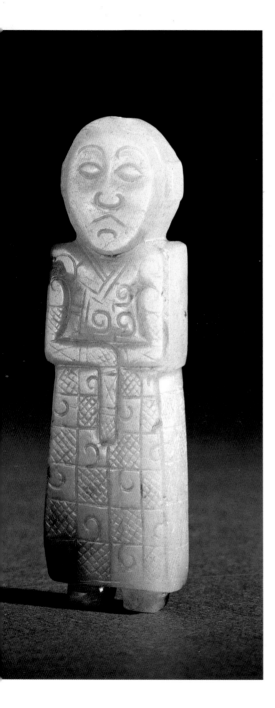

Translucent white jade figure. Eastern Zhou period (5th–4th century BC).

Many small carvings of human figures in the later Eastern Zhou and Han periods (475 BC–AD 220) were drilled through the centre to make a vertical hole. As beads, they were used as part of pendant sets or other ornaments, and the figures depicted must have been of high rank. This female figure has a large round head, eyes incised in hollows and a notched nose and mouth, forming a serious expression. Her hair is visible on the reverse, falling to the waist and banded together. She wears a neat bodice, slightly projecting beyond her shoulders. Below her folded hands is a long chequered skirt, of squares with criss-cross pattern alternating with squares enclosing commas. Her small feet project below the skirt. The fashion and fabric of the day are vividly depicted.

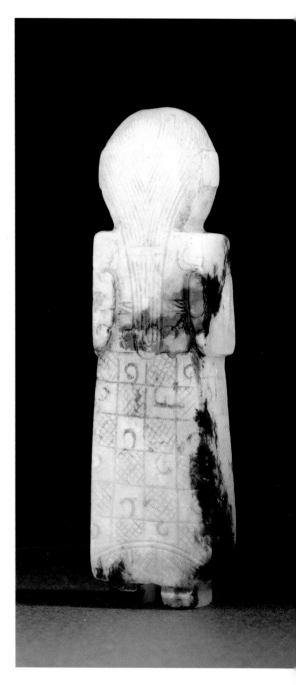

Jade hilt ornament.

Eastern Zhou dynasty (6th–5th century BC).

This jade fitting has a finely carved ornament of tiger or dragon heads in relief. In addition, a monster face is suggested at the bottom of the two main registers. Below the horns are two round eyes and a bulbous nose made of two S-shaped scrolls. There are two U-shaped ears. Both the horns and the sides of the face are made up of similar striated scrolls. Small areas of striation among the scrolls form the animal heads, and spare areas of ground are filled with stippling to suggest the granulation of gold.

The decoration of these fittings was much influenced by contemporary gold usage, such as the gold openwork sword hilt opposite. Gold is a soft metal and, when decorated using the lost-wax technique, it is easy to produce a complex decorative pattern. The fact that the jade carvers were able to replicate such intricacy of design on the much harder and tougher jade material is remarkable.

By this period jade was associated with protective powers, and a jade hilt allied to a metal blade would have been considered especially powerful. Many sword fittings of this period have been found in tombs so they were obviously considered essential items for the afterlife.

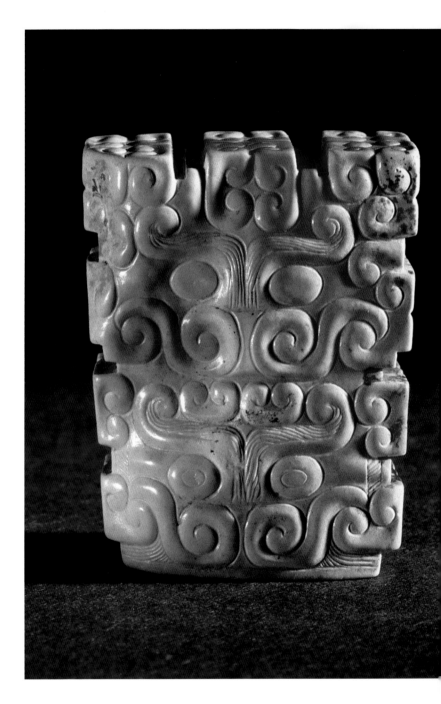

Gold openwork hilt for a sword.
Eastern Zhou period (6th–5th century BC).
The openwork decoration of this cast gold sword
hilt was derived from Central Asia. The design is
based on repeated units forming the image of a
winged dragon. The spirals and granulation make
up the dragon parts – a mass of bodies and
stubby wings with a sprinkling of heads. This hilt
shape is known from Central Asian and Bactrian
blades and is also characteristic of the steppe
region. Its rounded relief surfaces and fine
detailing reflect the light with great effect. It would
have been attached to a bronze or cast-iron blade
but was probably only intended for display, as the
gold would have been too fragile for actual use.

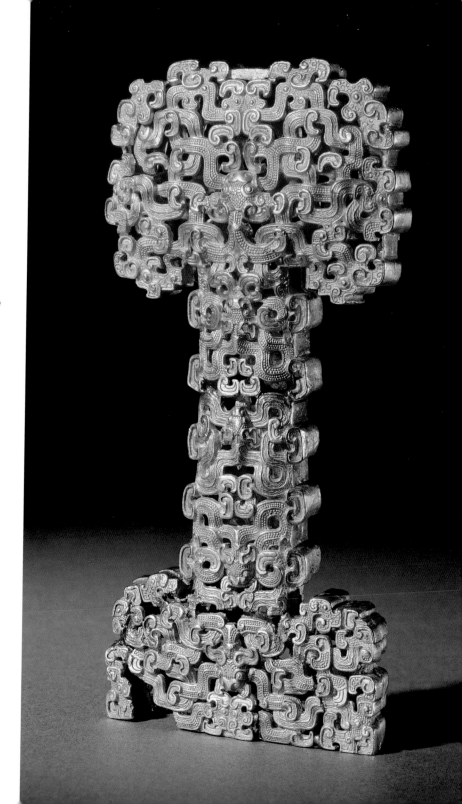

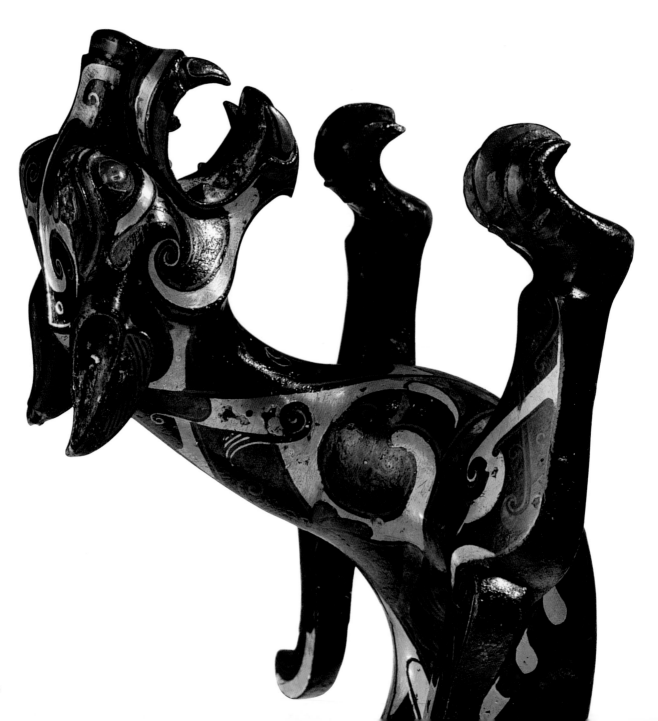

Bronze leaping feline inlaid with gold and silver. Eastern Zhou dynasty (475–221 BC).
This leaping feline was probably made as a tray support. At this period the Chinese did not use chairs but sat on the ground, so tables placed before them were like trays on short legs. Following a ritual revolution in the 8th century BC it was no longer so important to have the elaborate bronze ritual vessels for ancestral sacrifices, and many fewer were made. Lacquer, which could be very colourful, was becoming increasingly popular and to compete with this material, the bronze manufacturers used gold, silver and copper inlays, as well as semi-precious stones and even glass, to decorate their bronzes.

This bronze cat-like creature stands arched, with tail pointing to the sky, head back, bared teeth and bulging eyes. It is beautifully inlaid in gold and silver with stylized birds and snakes as well as abstract designs including scrolls, curved lines and tear shapes. The swirling, painterly and somewhat geometric style of decoration, the spiral and alternation of widths, and the bird-head terminals are all reminiscent of lacquer work of about the same period. Such imaginative decorative arrangements are probably related to the south of China.

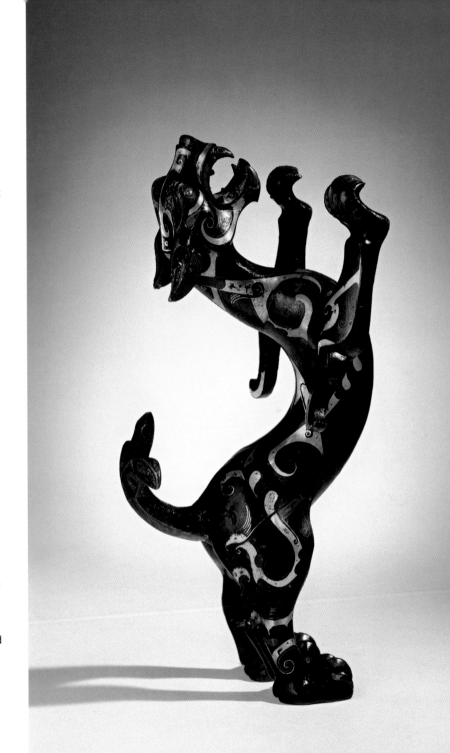

Lacquer toilet box.

Han dynasty (206 BC–AD 220).

This lacquered toilet box was made using the dry lacquer technique. First a core of wood was formed and covered in hemp and then with many layers of lacquer, each of which had to dry before the next could be painted on. When the object was finished it was possible to strip away the original core so that the finished item would be incredibly light and also impervious to the insects which might have attacked a wooden interior. It is painted with cloud scrolls and inlaid with silver.

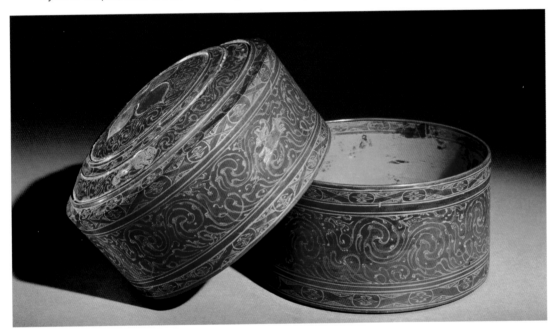

Fantastic heavenly creatures can be seen hidden among the flowing lines of the painted scrolls on this box. This style of decoration (see also p. 24) is associated with the south of China, which is sub-tropical and geographically very different from the more arid north. The folk religion of the state of Chu during the Warring States period (475–221 BC) involved a pantheon of gods, goddesses and deities, mythical beasts such as giant birds and dragons, and many varieties of plants and flowers. It was a strange mixture of mythology, unrestrained emotion, fiery imagination and romantic heroism, typified by the *Chuci*, a corpus of poetry supposedly written by a rejected minister of that period.

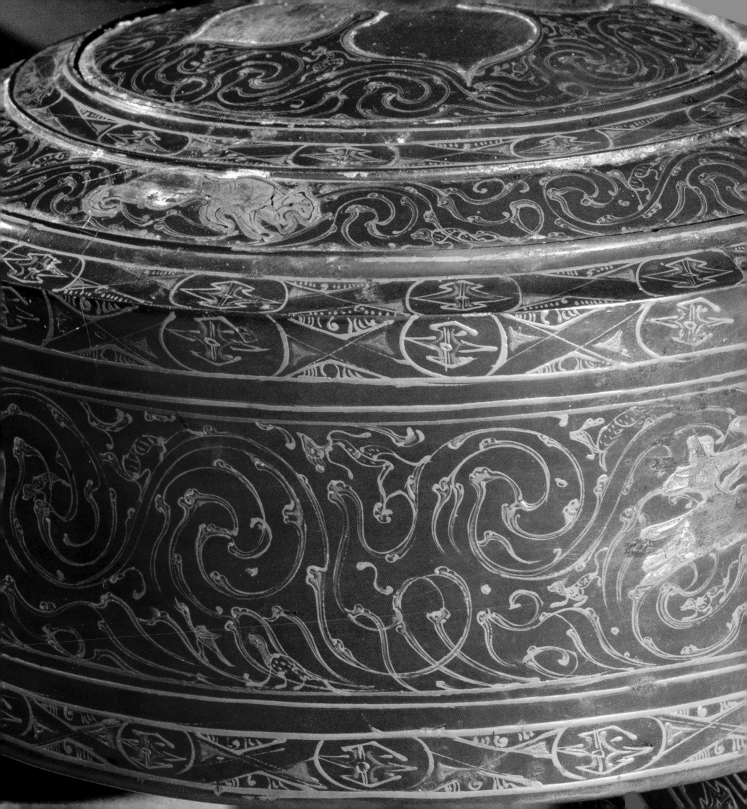

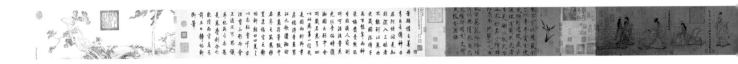

**Copy of a handscroll painting on silk, entitled
'The Admonitions of the Instructress to the
Court Ladies'. 5th–6th century** AD.
Original ascribed to Gu Kaizhi (*c.* 344–*c.* 406).

Gu Kaizhi is the first painter in China whose name
we know. None of his original works has survived,
but he has acquired a legendary status, both as a
painter and as a writer on Chinese painting. This
painting is now judged to be a 6th-century copy
of the original – the process of trying faithfully to
copy famous painters was seen as part of the
training of a painter as well as an act of reverence
for the past.

The scenes in the painting (nine of the original
twelve survive) illustrate an 80-line political
parody written by Zhang Hua (*c.* 232–300)
attacking the so-called immoral behaviour of an
empress. The protagonist is the court
instructress, who guides the ladies of the imperial
harem on correct behaviour. The painting is
executed in a fine linear style that is typical of
4th-century figure painting.

Similar pictorial motifs have been discovered
in contemporary tomb murals. The scroll consists
of quotations from the text, followed right to left in
each case by figure illustrations without any
background, or a slight suggestion of a setting.

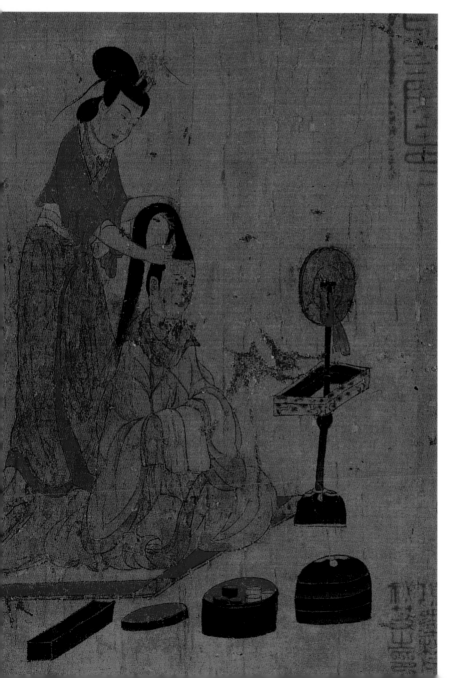

Scene 4: The toilette scene

One lady kneels on a square, red-bordered
mat, while another woman combs her long
hair for her. They both look into a circular
bronze mirror on a stand. On the floor to
their right are boxes made of black lacquer
(see p. 92). The painter is here illustrating the
admonishment that the palace ladies spend
too much time on self-adornment and too
little on self-cultivation.

Scene 7: The rejection scene

A court lady advances towards the emperor, who repulses her
with a gesture of his raised hand. The moral of this scene is
that 'No one can please forever'. The painter uses the figures'
gazes and gestures and their layers of clothing to create a kind
of zig-zag movement between them. The emperor's eye fixes
on the court lady. She glares at his outstretched hand, which
itself is directed towards her body and its forward momentum.
The drapery is portrayed with long, continuous, even
brushstrokes: movement is shown through the vitality of the
swirling draperies in a continuation of earlier painting
traditions.

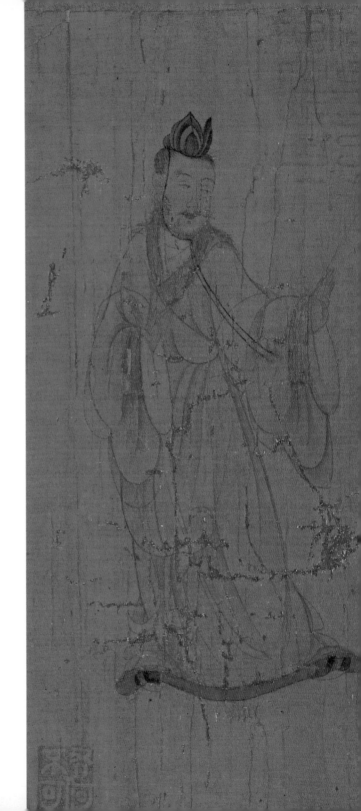

歡不可以瀆寵不可以專實生慢愛則極

遷致盈必損理育固然美者自美翩以

取尤冶容求好君子所沉結恩而絕寔

此之由

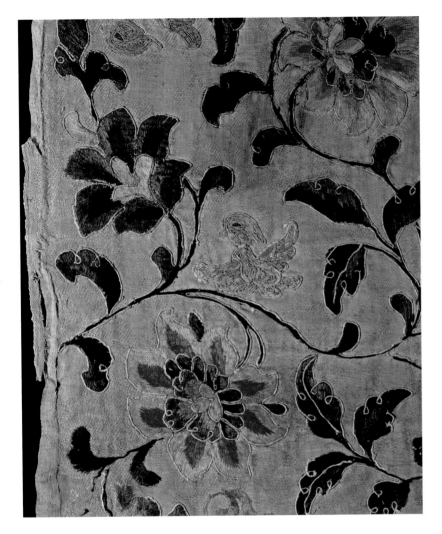

Silk and twill textile from cave 17 at Dunhuang. Tang dynasty (9th-10th century).
Silk was first worked in China in the Neolithic period, but the secret of how silk was made did not reach beyond China until about the 6th century AD. This gave the Chinese a monopoly which they exploited by exporting silk in huge quantities along the Silk Routes.

This textile bag or cover has a scroll of leaves and flowers of embroidered silk threads on a ground of cream figured silk twill, in which the ducks are formed of couched, gold-covered thread. The scroll design with flowers and birds occurs in ceramics and other decorative arts from the Tang dynasty onwards.

The flowers, leaves and birds are in satin stitch. The stems are indigo, the leaves green, while the flowers have outer and inner circles of petals and a mass of stamens at the centre in different combinations of orange, white, red, yellow, brown, pink and blue. The outside edges of the flowers and the divisions of the leaves were originally outlined in silver, which has mostly disappeared.

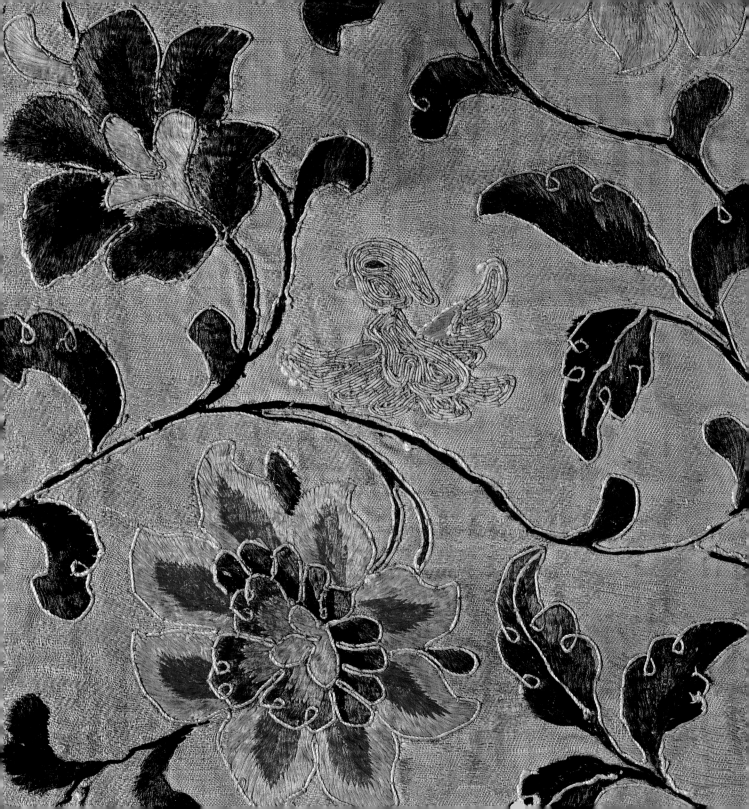

Fascination of Nature,
handscroll painting dated AD 1321,
ink and colours on silk.
Yuan dynasty (1279–1368).

This handscroll is a rare example of a signed and dated painting from the Yuan dynasty. The subject matter is that of animals and insects feeding off each other. Such paintings belong to a category known as 'plants and insects' which dates back as far as 1120 during the Northern Song dynasty. The colophon tell us of the deeper significance of the subject matter: the beauty and brightness of the natural world mask the confusion and disorder caused by the fight for survival.

It reflects the dilemma faced by many Chinese of the period: whether to work for the new Mongol dynasty and survive, or remain loyal to the fallen Song imperial dynasty and starve. During the Yuan period concealed meanings were often found in artistic works for, under Mongol domination, the literati could only express their frustrations in subtle ways. The Mongols abolished the state examination system by which Chinese scholars had traditionally been recruited for government service. In any case, many refused to serve the Mongols, even when the exams were restored, and chose instead to live in seclusion, turning their talents to painting or writing.

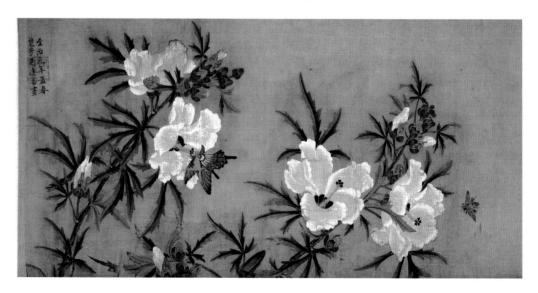

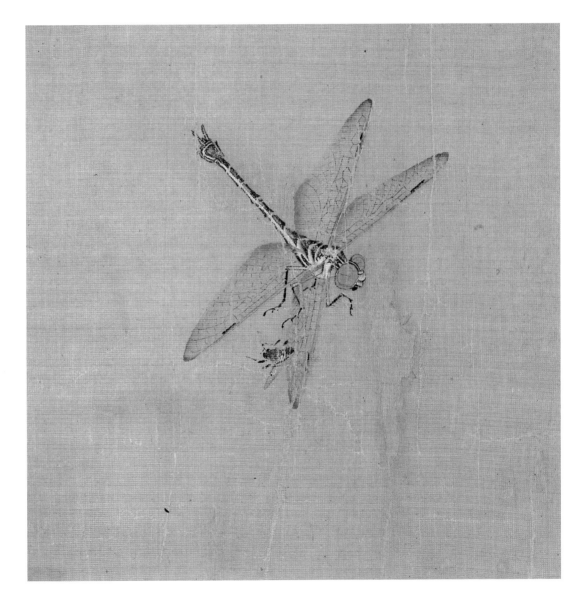

Both the animals and plants in this painting are very accurately represented. At the very beginning, at the right end of the scroll, we see the theme of the insects' struggle for survival: in mid air a dragonfly tumbles a much smaller insect, perhaps a fly, with unmistakable predatory intent.

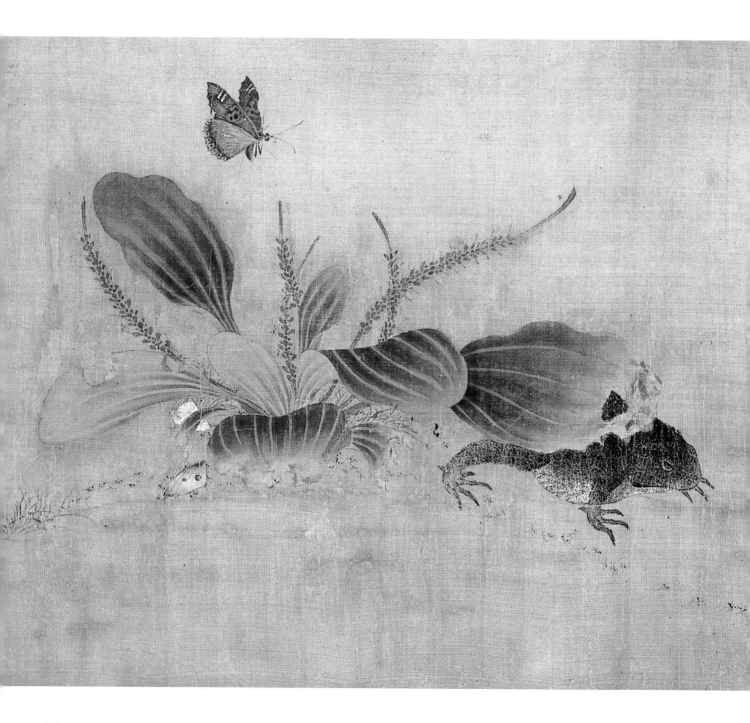

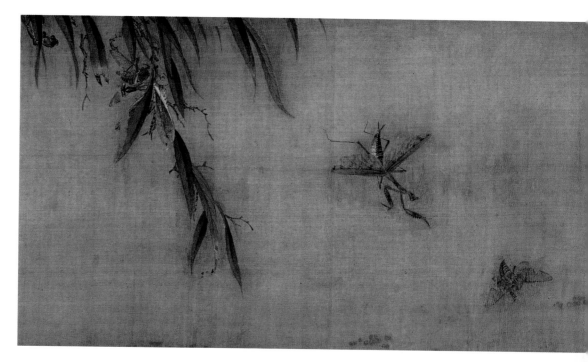

Reading from the right we see a cicada which has landed helplessly on its back, while a praying mantis swoops down in flight, its head tilted in greedy anticipation of a good meal. In the tree we then see the cicada firmly grasped in the mantis' forelegs and already losing hold of its perch. Just above, in the top left corner, a small bright blue tree frog witnesses the attack.

On the ground below, barely indicated with a few circular dots of bright green arranged in short rows parallel to the lower edge of the scroll, some ants mill around a hapless small butterfly, its upper and lower left wing seen from the underside, struggling and already partially dismembered. Its other wing lies damaged under the plantain at the left.

The ants' procession from the lower right leads to a fine specimen of the common plantain, here shown flowering and seeding, where under its leaves a wily toad lies in wait. It is not hard to imagine its lightning tongue taking easy prey from the endless stream of ants as they pass close by.

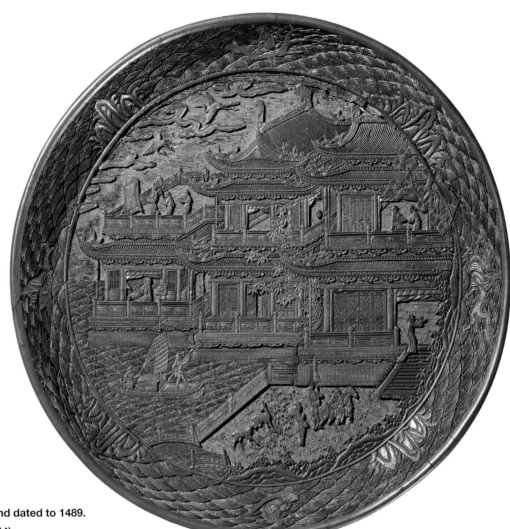

Lacquer dish, signed and dated to 1489.
Ming dynasty (1368-1644).

This carved polychrome lacquer dish is decorated with a scene from a famous 4th-century drinking and poetry party at the Lanting (Orchid Pavilion) in Zhejiang province. The sky is full of clouds and cranes, birds symbolic of immortality. The party arriving in the foreground is accompanied by deer, also associated with immortality, and the Islands of the Immortals rise out of waves around the border of the dish.

The bracketing and tiling of the buildings are executed with great intricacy. Such decoration was time-consuming and expensive, as it required many coats of lacquer to be applied, sometimes of several different colours, before the decoration could be carved to achieve a 3-D effect. The carver has signed his name and the date of carving around the door of the pavilion. It is most unusual for a craftsman to sign his name on such an object, as most such crafts were made anonymously. The name of Wang Ming of Pingliang, thought to be in Gansu province, is clearly visible.

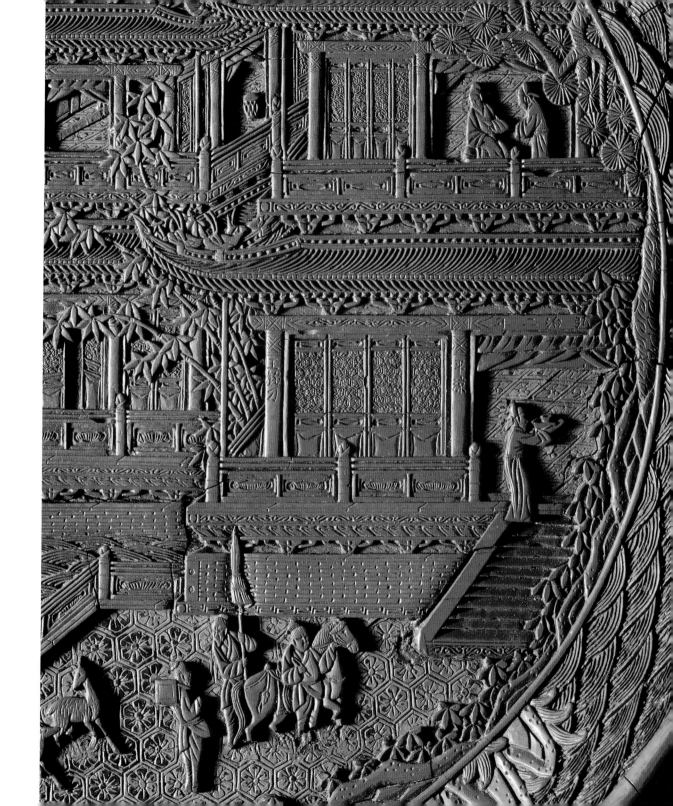

Kuncan (1612–73), Winter, dated 1666, album leaf mounted in handscroll form, ink and colour on paper.
The album to which this leaf belongs, representing the four seasons, is one of Kuncan's finest works. Chinese landscape painting dominated the artistic tradition and was claimed to have a spiritual and aesthetic value above other categories of painting. From the Song dynasty onwards, Chinese theorists began to distinguish between the professional and the amateur ideals in painting. Painting was regarded as expressing the views of the cultivated individual, a means of self-expression. Artists were not so concerned with formal likeness and artistic style but more with the character and intellectual attitude of the individual. Kuncan was an artist who practised a more individualistic style than had been common earlier, but he still showed enthusiasm for the long tradition of using brushwork to convey a personal experience rather than to create an exact representation.

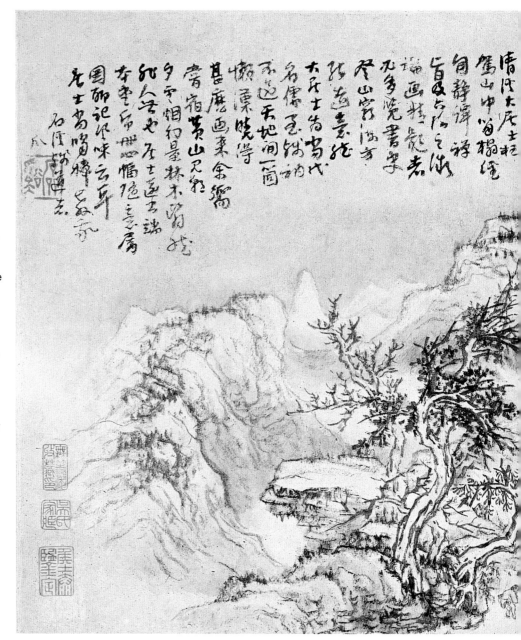

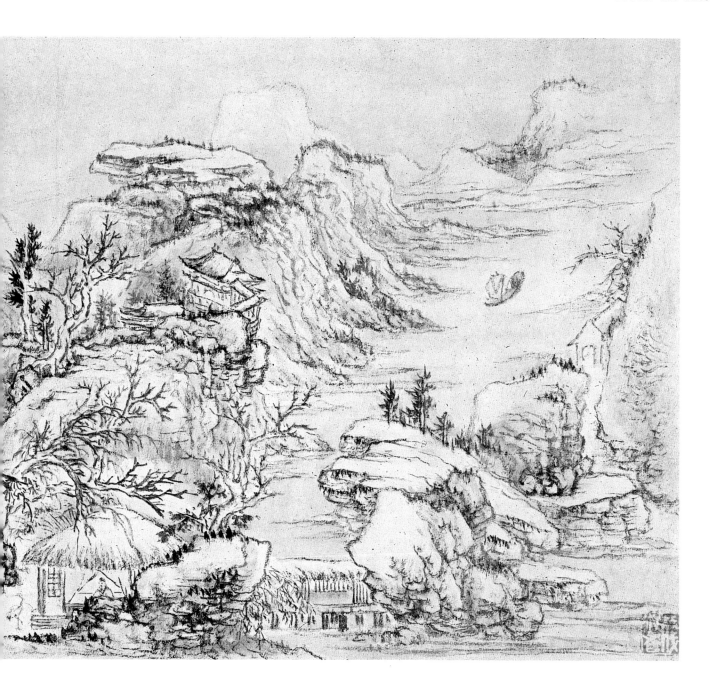

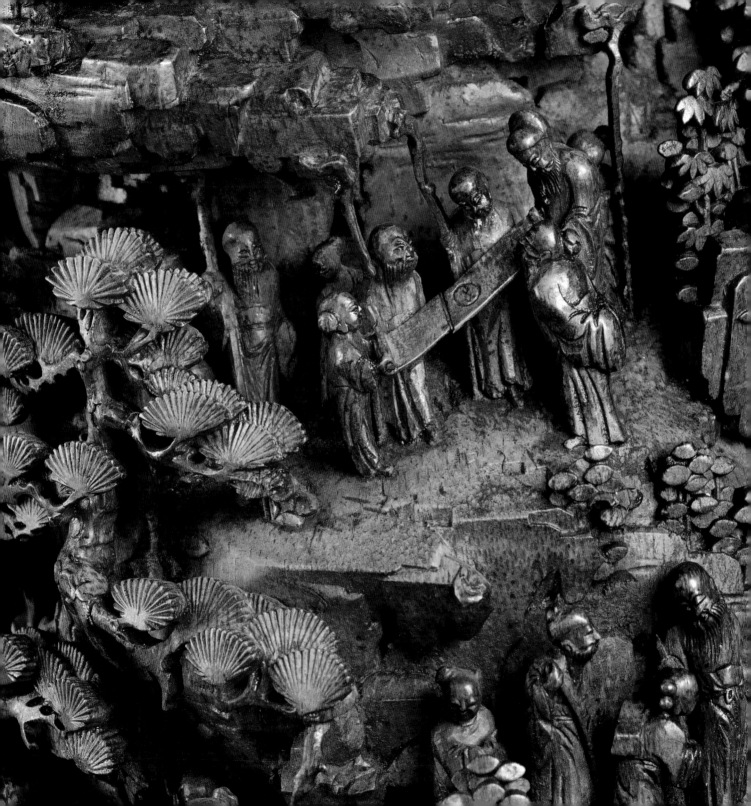

Bamboo miniature mountain of bamboo root.

Qing dynasty (18th century).

This miniature mountain is carved to look like a rock, with pine trees symbolic of longevity and an assemblage of Daoist immortals. The mountain would have been placed on a scholar's desk or in a cabinet as an object of contemplation. Such small representations of mountains were made in various materials including jade, ivory and turquoise. They signified the retreat of the scholar from official life and offered the alternatives of a reclusive existence or of individual expression in the face of strong governmental bureaucracy. Such mountains were also seen as a route to paradise.

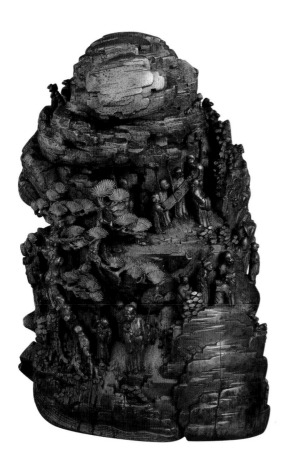

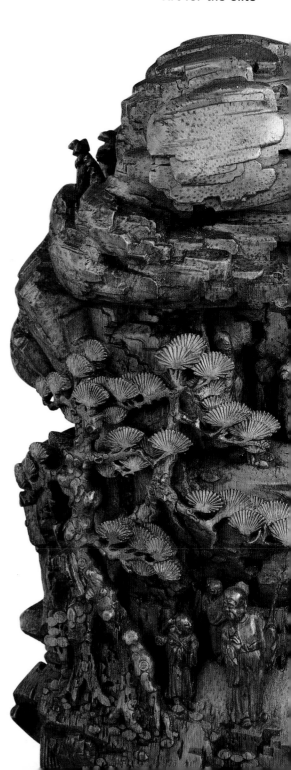

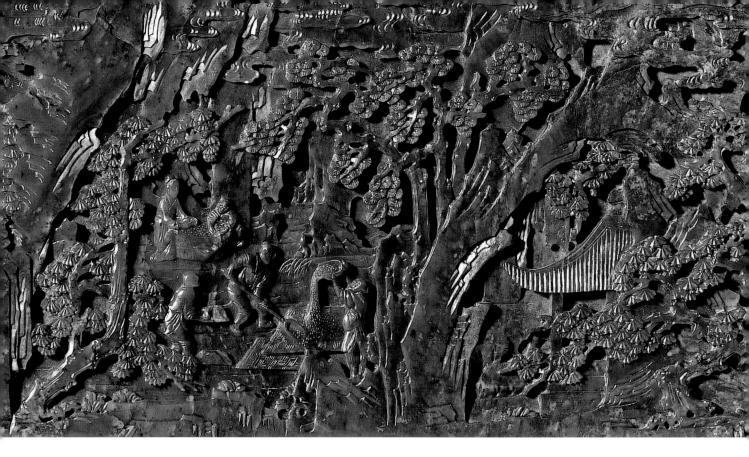

Jade brush pot.

Qing dynasty (18th century).

The two principal scenes on this scholar's brush pot show the winnowing of grain and the stacking of sheaves. The surface of the jade is treated rather like a sheet of paper, and subdivided like a handscroll. The carver took his specific subject matter as well as the general composition from available examples of painting and printing. He then used carving techniques to produce the effects of a painting. For instance, the deeply scored lines in the rocks mimic the angular lines usually employed to render rocks with a brush in ink, and the depiction of the pines and buildings demonstrates similar painting conventions.

In the winnowing scene above, a man pours grains on to a mat to his left, where it is winnowed by another man holding a scoop or shovel on a long staff. Behind this second man is a third, holding an empty scoop. In the background is a basket of grain, with a woman seated to the left and a second person to the right. Such scenes as this and the one further to the right were copied from manuals such as the *gengzhi tu*, an agricultural and sericultural manual that was reprinted many times over the centuries.

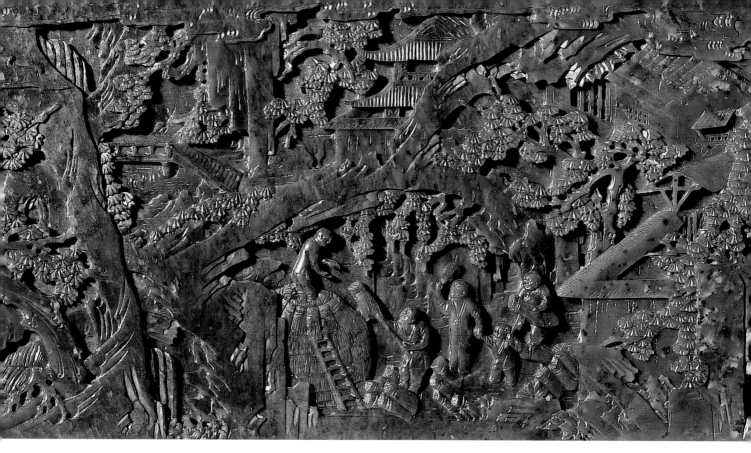

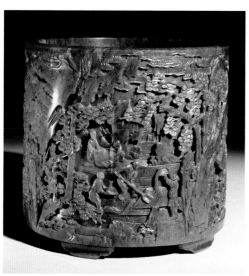

The other scene shows the stacking of sheaves with four principal figures, including one on top of a rick, against which a ladder is leaning. Below a man holds up a sheaf to stack on the top with a long pole. An older man is watching with a fan in his hand. The fourth man is bringing forward more sheaves to stack.

Porcelain vase with overglaze enamels.
Qing dynasty, Qianlong period (1736–95).

This massive vase is covered in *famille rose* enamel decoration. The opaque white enamel of the *famille rose* palette could be mixed with other enamels to produce subtler shades – the impact is perhaps best seen on the delicately painted fine porcelains of the immediately preceding Yongzheng period (1723–35). The *famille rose* palette became very popular with foreigners, and during the 18th and 19th centuries many ceramics with this palette and the related ones of *famille verte* and *famille noire* were exported by the Chinese around the world.

The flowering peach branch decorating this vase was a subject well known on Yongzheng wares, but here on a scale and with a complexity typical of the adventurous style of Qianlong porcelain. Peaches are a symbol of long life in China. The Queen Mother of the West, who ruled over one of the paradises, had peach trees that bloomed for thousands of years. During this period many objects were also made in the shape of peaches, which were considered auspicious.

6

Art for the masses

Mass-production has been a speciality in China from earliest times. For instance, the First Emperor of China, Qin Shihuangdi, was famously able to organize the mass-production of thousands of earthenware figures for his tomb. His craftsmen used basic forms such as legs, torsos and heads, which were then varied by individual modelling of faces and hairstyles. The use of modules also increased the speed of production.

Other examples of mass-production can be seen in, for example, a lacquer cup of the Han dynasty (206 BC–AD 220), which is inscribed with the names of all the different craftsmen and their separate functions, indicating a high degree of division of labour. Silk was mass-produced from early times in China and exported along the Silk Routes, despite a complicated production cycle. In fact, the designs used on silk also influenced those used on cheaper materials such as ceramics.

Porcelain was also mass-produced at the kilns in Jingdezhen and exported to other countries which had not yet discovered how to make it. In the Yuan dynasty (1279–1368),

Woodblock print of Kitchen God.
Qing dynasty (1862–75).

large numbers of porcelain items were made specifically for export to the Near and Middle East, with vessel shapes and dense geometric patterns designed to appeal to the taste of the Islamic market. In the 17th and 18th centuries, hundreds of millions of pieces of porcelain were exported to the West in the bottom of trading ships. One shipwreck, dated 1640, held 25,000 pieces of unbroken blue and white Chinese porcelain.

The invention of woodblock printing led to the widespread dissemination during the Ming dynasty (1368–1644) of illustrated books and colourful, decorative pictures. These often formed the basis for designs on ceramics and other decorative arts. In Ming and Qing dynasty China, popular prints were produced depicting household gods, enabling ordinary people to decorate their homes at festival times.

Woodblock printing was also employed in the 20th century as an art form associated with the ordinary people. The Chinese Communists made use of it for propaganda purposes and present-day artists have carried on the woodblock printing tradition, producing a variety of new interpretations of this art form for the masses.

Snow over the Waterside Village, 1998, watercolour woodblock print in ink and colour on paper by Wu Jide (born 1942).

Ceramic lidded jar with *sancai* (three-colour) glazes. Tang dynasty (first half 8th century).

The shape of this lidded jar is known as a *wannian* ('myriad year') jar because it was favoured as a burial type. The *sancai* palette was very popular during the Tang dynasty, one of China's golden ages, when the empire was the richest and most powerful political unit in the world. It was characterized by cultural brilliance, territorial expansion and great prosperity. The capital Chang'an (modern Xi'an) was at the eastern end of the Silk Route and was a wealthy, cosmopolitan city. The eclectic motifs, technical virtuosity and confidence of Tang craftsmen is reflected in the bold and colourful ceramic decoration of this period.

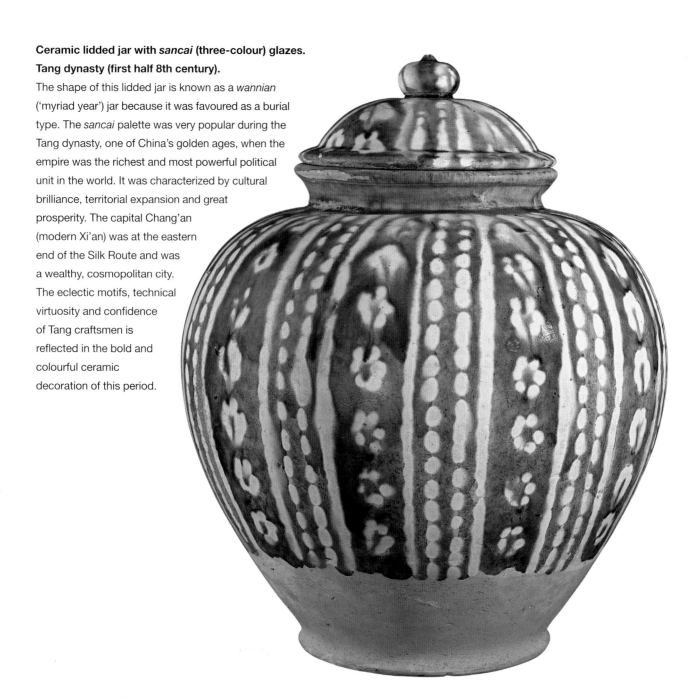

The decoration has been achieved by use of a resist, either of powdered kaolin or of wax. The stripes and florets are typical of the ornament on polychrome woven silk of the period.

Wannian jars occur with monochrome lead glazes from the *sancai* palette and also, less frequently, in white and greenware.

Cizhou ware ceramic pillow.

Song dynasty (late 11th–early 12th century).

This leaf-shaped pillow is set on a square base. It was probably coated first with white slip and then with black slip, which was incised and then cut away to leave the design of the dancing bear. A transparent glaze was then applied. The term Cizhou ware refers to a type of sturdy stoneware produced at many kilns throughout the northern Chinese provinces of Hebei, Henan and Shaanxi. They tend to be heavily potted and boldly decorated, with freely drawn designs. They are often referred to as 'popular' ceramics as opposed to the more refined wares produced for the imperial court.

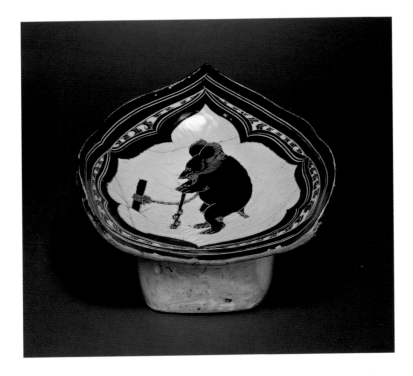

The design is of a dancing bear tied to a pole. No doubt such bears were a form of entertainment in Chinese marketplaces – 'boxing' bears can still be seen today. Bears were particularly popular because the Chinese word for bear (*xiong*) sounds the same as the Chinese word for bravery. There are many examples of bears decorating materials such as ceramic and jade, both as sculptures and as supports, particularly during the Han dynasty (206 BC–AD 220).

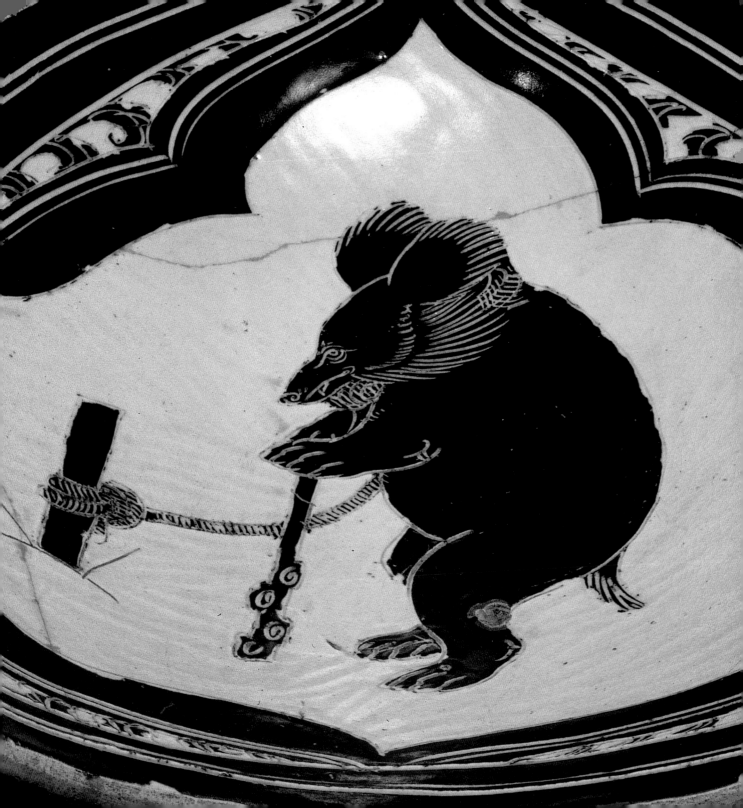

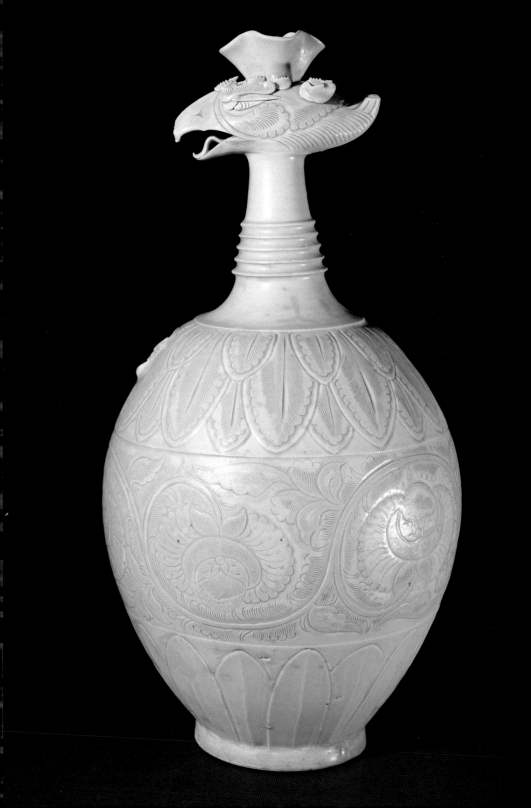

**White porcelain
phoenix-head ewer.
10th–11th century** AD.
This ewer, which is
covered in a green-tinged
glaze, is widely regarded
as the finest known
example of the phoenix-
head vessel type. It is not
established whether it
was made in a northern
or southern kiln, as such
phoenix-headed ewers
were made in Liao
territory in the north as
well as at the Xicun kiln
site in Guangdong
province in the south. At
one time this ewer had a
spout but does not seem
to have ever had a
handle. This similarity to
a more vase-like form
may point to a northern
origin, but no closely
comparable examples
have yet been excavated.

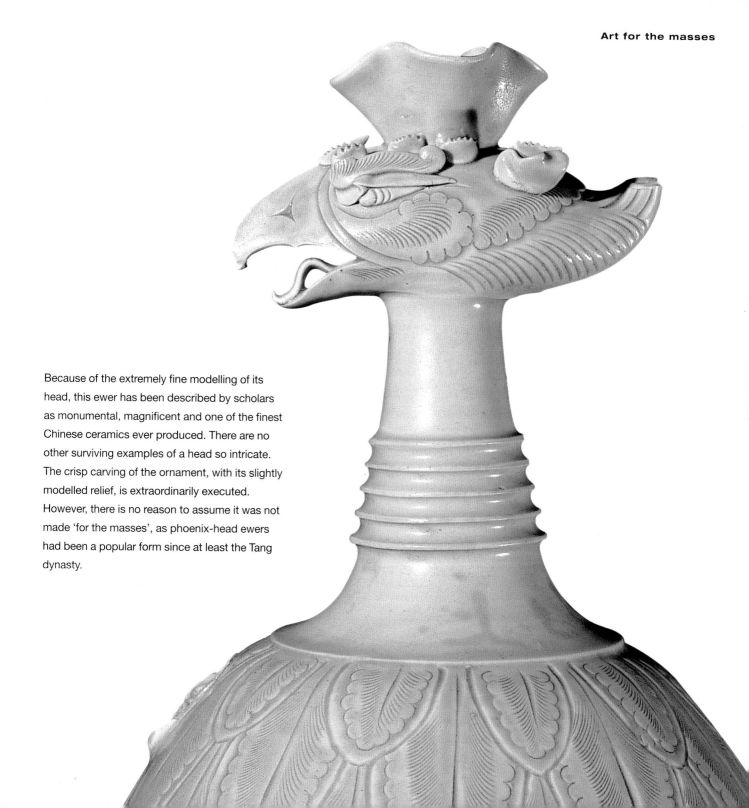

Because of the extremely fine modelling of its head, this ewer has been described by scholars as monumental, magnificent and one of the finest Chinese ceramics ever produced. There are no other surviving examples of a head so intricate. The crisp carving of the ornament, with its slightly modelled relief, is extraordinarily executed. However, there is no reason to assume it was not made 'for the masses', as phoenix-head ewers had been a popular form since at least the Tang dynasty.

**Underglaze blue and white porcelain dish.
Yuan dynasty (1330–68).**
This large heavily potted dish was made for the
Persian market. The cavetto is decorated with a
lotus scroll, reserved in white. In the centre are a
peony flower, bud and foliage, all reserved in
white on a blue ground, and surrounded by
chrysanthemums. This is an Islamic-inspired form
of decoration. Blue and white porcelain was
much appreciated in the Near East where, since
the 11th century, attempts to use the native
cobalt ore to produce it had been foiled by
inappropriate body materials.

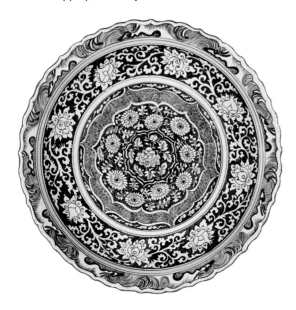

Large dishes such as this (it is
over 45 cm in diameter and 8 cm
high) were made at Jingdezhen
specifically for the Middle Eastern
market, where plates were
required for communal eating.
The densely packed style of
decoration is known in Islamic
metalwork and architectural
decoration rather than inspired by
Chinese decorative motifs.

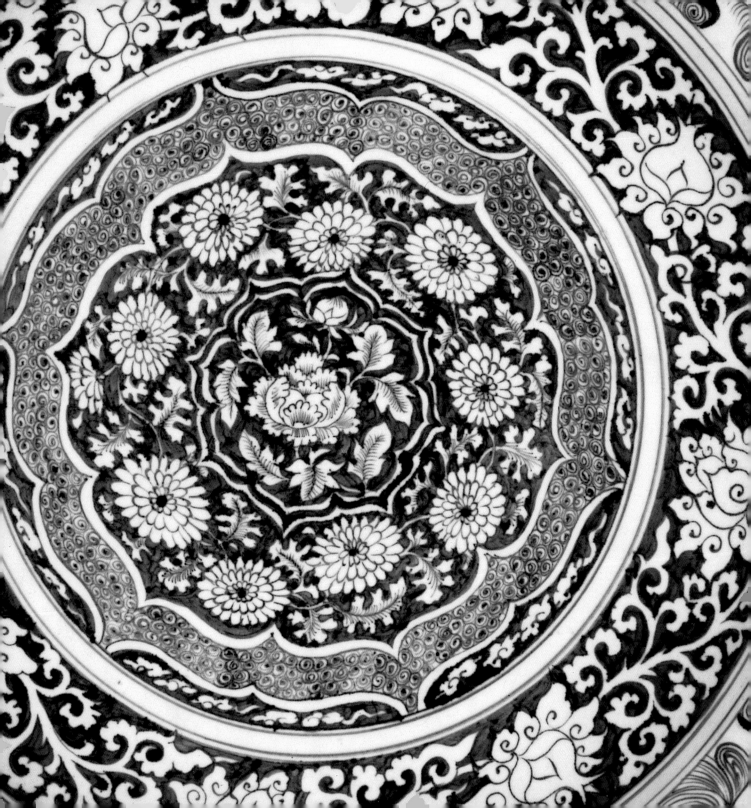

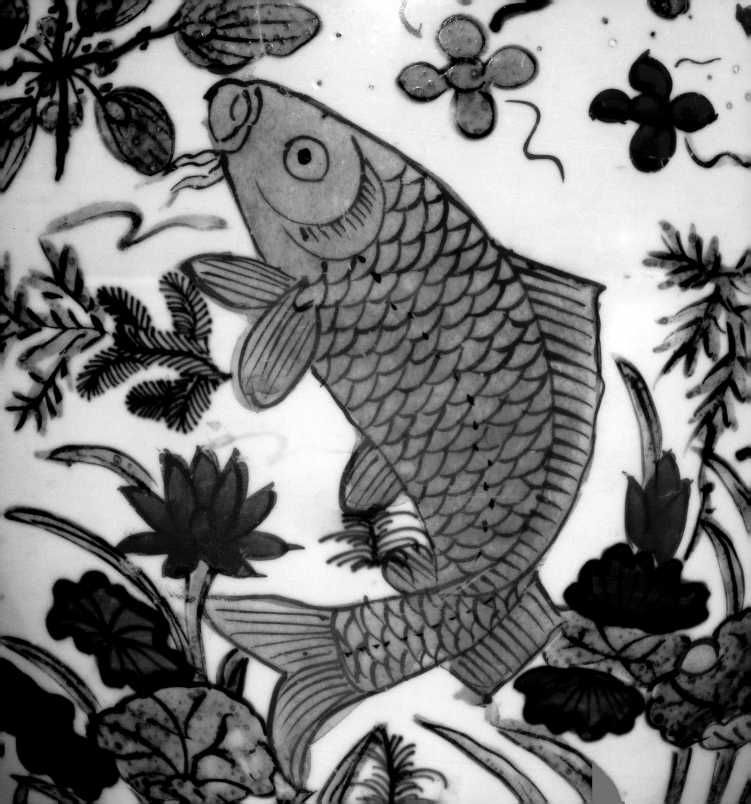

Jar with underglaze blue and overglaze enamel decoration. Ming dynasty, Jiajing period (1552–66).

This is one of a pair of porcelain jars with underglaze blue and overglaze enamel decoration. This required two firings: the jars would first have to be fired after the underglaze blue was applied, and then a secondary firing would be needed for the overglaze enamelled colours, at a lower temperature to prevent the enamels from melting into the glaze. The jars are thickly potted and the decoration is boldly rather than carefully executed. Later Ming enamelled wares such as this are notably coarser than the 15th-century wares that preceded them.

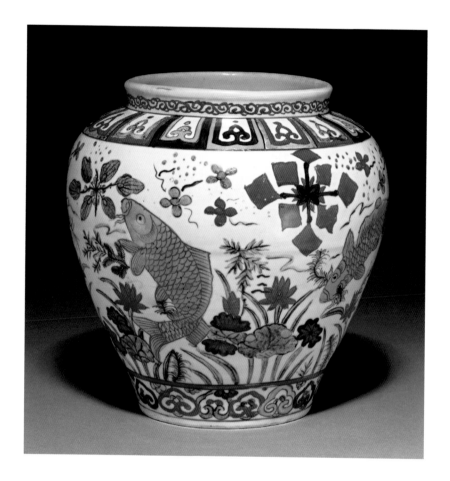

The breeding of ornamental goldfish, which began in the Song dynasty during the reign of Huizong (1101–25), was by the 16th century a popular domestic pastime, and therefore a popular and widespread motif. In addition, because the Chinese word for fish is pronounced 'yu', as is the word for abundance (though they are written with entirely different characters), fish were considered an auspicious motif and were widely used on a variety of media.

Bronze *you* inlaid with gold and silver. Qing dynasty (18th century).

Bronze vessels were first cast in the Shang dynasty (*c.* 1500–1050 BC). They were used ceremonially to offer food and wine to the ancestors and were often buried in sets with their owners. The *you* was a wine vessel in use from the Shang to the middle of the Western Zhou dynasty (1050–771 BC).

This example is an archaistic one, made during the Qing dynasty (1644–1911) as a copy of the ancient shape. Such copies were made to show respect for past traditions and were inspired by catalogues of antiques printed either by the imperial court or rich antique collectors.

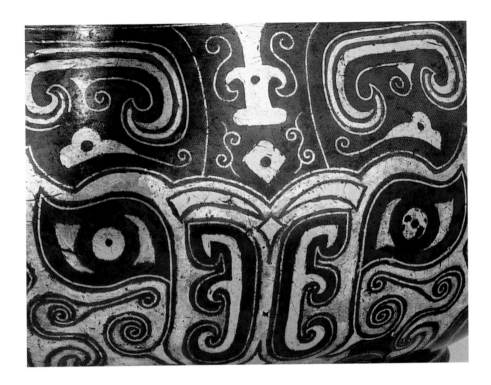

Gold and silver inlay was not used on bronze until the Eastern Zhou period (771–221 BC), so the use of inlay here is anachronistic. The Chinese felt that by copying old and revered antiques they were expressing a reverence for the past, particularly that of the Zhou dynasty, during which Confucius lived, and they talked of an idyllic period of golden rule at the beginning of that dynasty. The *taotie* mask on the vessel can be seen as a quirky pastiche of the original monster mask decoration (see p. 18).

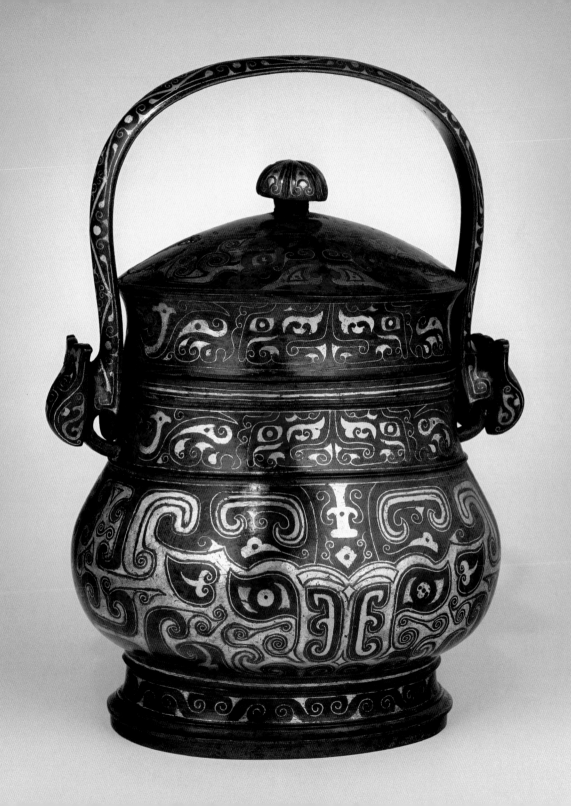

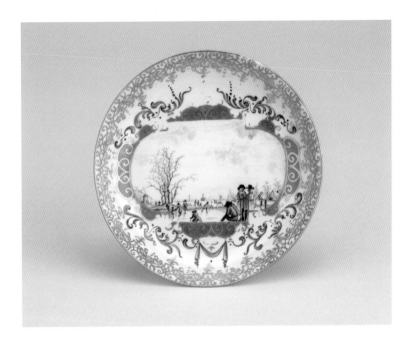

Porcelain decorated in pink and gold overglaze enamels.
Qing dynasty, Yongzheng period (1723–35).

This saucer was made in China and painted by Chinese artisans with a
Western scene of skaters. Many such porcelains made for export were
painted with scenes copied from pictures sent by the commissioning patron
from Europe. These 'export' ceramics were made in huge numbers and were
transported as special orders on ships belonging to the various European
East India companies who traded with China in the 18th and 19th centuries.

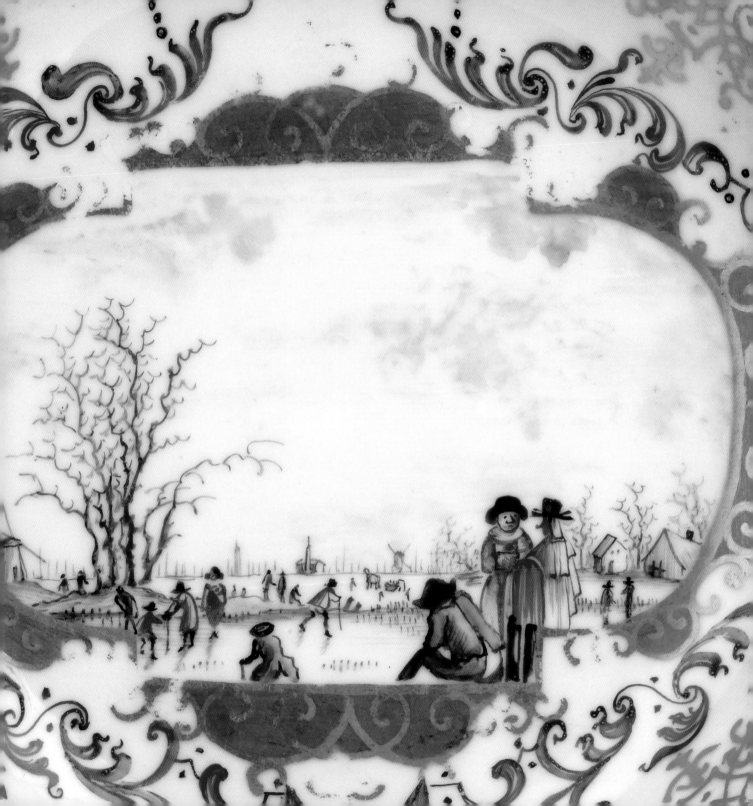

Inside-painted glass snuff bottle, dated midwinter 1901 and painted, signed and sealed by Ma Shaoxuan (1867–1939). Qing dynasty.

Snuff was most probably introduced into China by the European missionaries who presented the Chinese emperors with gifts of snuff boxes from Europe. However, such boxes were not sufficiently airtight for the humid Chinese climate, which turned the snuff rancid. So the Chinese adapted medicine bottles, which had a cork to seal them, into snuff bottles. These were then made in a variety of materials, including some of the finest wares produced by Qing dynasty craftsmen. Snuff-taking became a very popular pursuit, particularly after it was adopted by the Kangxi emperor (1662–1722), who commissioned many snuff bottles from his imperial workshops. The custom spread to the whole of China, and snuff bottles were made in huge quantities.

Inside-painted bottles were first made in the 19th century, usually of glass, rock crystal or a pale chalcedony. The inner surface of the bottle is first roughened to hold the paint, which is applied through the neck of the bottle by means of a narrow bamboo pen with a special handle and a sharp right-angled bend near the nib. The painting is always done in reverse – foreground first and background later. No corrections are possible, so each line, dot and calligraphic stroke must be perfect. This bottle is signed, dated and sealed by the maker just over the shoulders of the Qiao sisters, famous beauties from a popular story of the Three Kingdoms period (221–80).

丑仲冬
馬少宣
寫圓

131

Woodblock print of door god, dated to the Tongzhi emperor's reign (1862–75), ink and colour on paper, from Weixian in Shandong province. Qing dynasty.

This is a picture of the kitchen god (here called Zao Jun) with his wife. The kitchen god is a very important deity, and above his head it is written that he is in charge. A week before the evening of the lunar New Year, families would take down old pictures and burn them – the ascending smoke was considered to be the god ascending to heaven to report to the Jade Emperor on the family's activities throughout the year. Before burning the image, honey was smeared on the god's lips, either to paste his lips together or to sweeten his report. The night before New Year, a new image would be pasted up so that the god would have a place to reside when he returned from heaven.

Below the altar are a cock and a dog, the two domestic creatures of the hearth and home. They are also both *yang* animals, as opposed to *yin*. The pot in front of the table is the Treasure Pot that, hopefully, Zao Jun will fill. The objects on the table are offerings to keep him in a good humour.

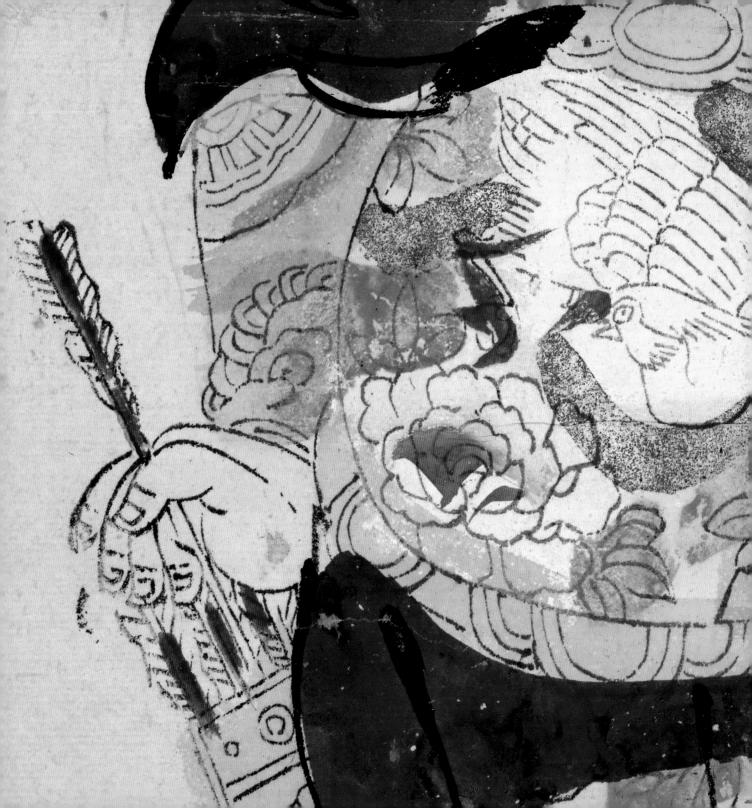

Woodblock New Year print of a door god, ink, colour and varnish on paper. Qing dynasty (1644-1911).

The woodblocks were printed in two colours, to which other colours were applied by hand. Blocks for New Year prints were produced over many decades and printed annually for the lunar New Year. As with the kitchen or stove god, this guardian figure would be renewed each year before the lunar New Year eve. These ephemeral prints rarely survive, as they were meant to be burned. This print is particularly interesting because it was in the founding collection of the British Museum in 1753.

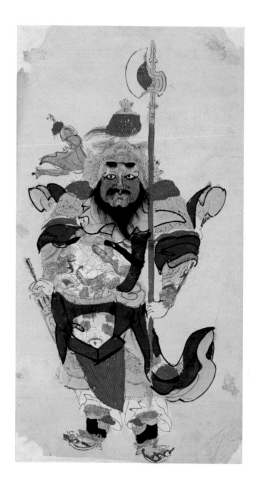

Such guardian gods were generally made in pairs with their faces portrayed full frontally, but the bodies were usually turned slightly to face each other across the door. To signify his rank, the door god wears armour with a bird displayed on the front, which is generally a sign of civilian rank. Beneath the bird is a peony, and together the bird and peony make a rebus ('white-headed bird on a peony bush') which means 'riches and honour until old age' – a very suitable wish for the New Year. Some of these New Year prints are quite crudely executed, but this is a more sophisticated example.

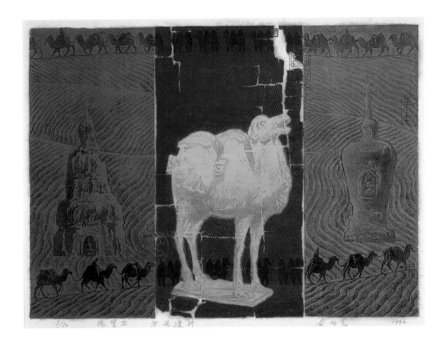

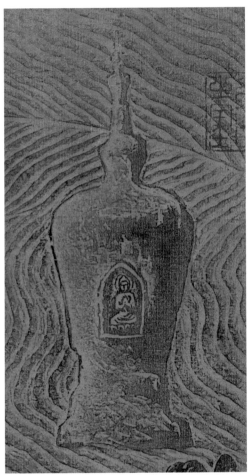

Woodblock print Treasures of the Desert, by Yu Qihui, 1992, watercolour woodblock print in ink and colour on paper.

In the post-Cultural Revolution period, many Chinese artists were seeking new subject matter and new artistic approaches. Yu Qihui developed a new printing technique called 'dab printing', in which he applied colour by dabbing, using a technique derived from Chinese ink rubbings. He combined this with conventional printing techniques using water-soluble pigments. A depth of colour is built up through repeated printings and half-tones to create a three-dimensional effect. His Treasure series, produced from 1992 onwards, represents scenes and sculptures from famous national monuments of China, including imperial tombs, Buddhist cave shrines and Silk Road sites.

The Silk Route reached its height during the Han dynasty (206 BC–AD 220) and again in the Tang dynasty (618–906), when camels regularly plied the desert routes carrying goods from China to the West, including silk and lacquer, and bringing perfumes, spices and horses to the Chinese.

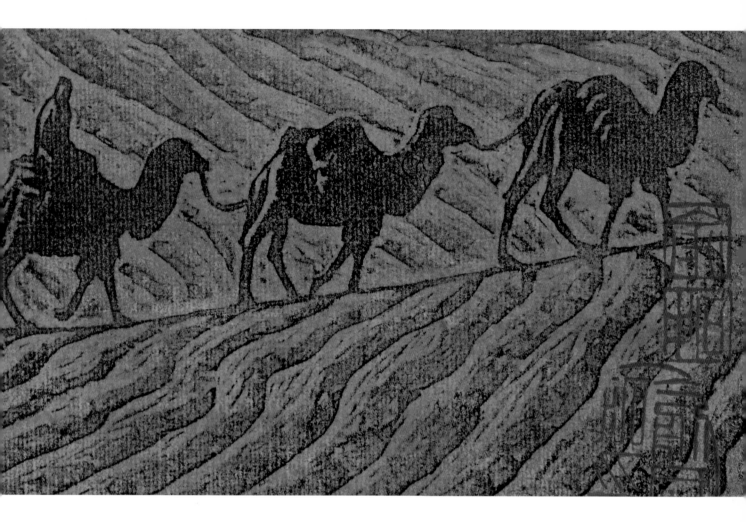

Buddhism was also very popular during the Tang dynasty, and it was a period when many shrines were built, wherever Buddhist pilgrims stopped to pray on their journeys to India to collect sutras for translation.

Here we can see how the artist has built up depth to portray the sand dunes and the camels plodding over them. The ruined shrines and the seals both convey the impression of antiquity.

Warm Water of the Dragon River, 1984, multi-block woodcut printed with water-soluble ink and blind-embossing, by Liang Dong (born 1926).
One of the many Chinese inventions was printing (along with paper, gunpowder, silk and the compass), and woodblock printing was particularly widely used for duplicating Buddhist tracts from the Tang dynasty. The Chinese led the world in printing until Gutenberg's discoveries in the 15th century in Europe. In the late 1920s, Lu Xun (1881–1936) revived Chinese print making and introduced European and Russian styles as a new popular form of graphic art. The idea of fine art prints, which are now produced in art schools throughout China, grew out of this movement.

This woodblock print portrays a spring scene. The desolate Dragon River begins to thaw, and only a few small birds stand on the nearest ice block to lend a sense of scale. The print is dominated by strong horizontal bands, in contrast to the narrow, vertical format of the traditional Chinese hanging scroll. It represents a new trend that began in the 1980s, in which landscape was depicted as a subject in its own right. Bold white highlights are created by the embossing of the white paper, which also outlines the crests of the hills and the rich black of the water. This is a very different technique to that of outlining in black ink, as employed in brush painting.

7

Further information

FURTHER READING

Historical and geographical background

Ebrey, P. B, *The Cambridge Illustrated History of China*, Cambridge 1999

Paludan, A., *Chronicle of the Chinese Emperors: The Reign-by-Reign Record of the Rulers of Imperial China*, London 1998

Twitchett, D. C. & Fairbank, J. K., *The Cambridge History of China*, Cambridge 1978

Wintle, J., *The Rough Guide Chronicle: China*, London 2002

General works on Chinese art

Clunas, C., *Art in China*, Oxford 1997

Fong Wen, C. & Watt, J. C. Y., *Possessing the Past: Treasures from the National Palace Museum Taipei*, New York 1996

Hearn, M. K., *Splendours of Imperial China; Treasures from the National Palace Museum, Taipei*, New York 1996

Rawson, J. (ed.), *The British Museum Book of Chinese Art*, London 1992

Archaeology

Los Angeles County Museum of Art, *The Quest for Eternity*, Los Angeles 1987

Rawson, J. (ed.), *Mysteries of Ancient China: New Discoveries of the Early Dynasties*, London 1996

Rogers, H. (ed.), *China 5, 000 Years: Innovation and Transformation in the Arts*, New York 1998

Yang Xiaoneng (ed), *The Golden Age of Chinese Archaeology: Celebrated Discoveries from the People's Republic of China*, London and New Haven 1999

Yang Xiaoneng (ed), *New Perspectives on China's Past. Chinese archaeology in the twentieth century*, 2 vols, Yale University Press, The Nelson-Atkins Museum of Art 2004

Bronzes

Fong Wen et al., *The Great Bronze Age of China*, New York 1980

Kerr, R., *Later Chinese Bronzes*, London 1990

Rawson, J. & Bunker, E., *Ancient Chinese and Ordos Bronzes*, Hong Kong 1990

Rawson, J., *Chinese Bronzes: Art and Ritual*, London 1987

Buddhist art

Juliano, A. & Lerner, J., *Monks and Merchants: Silk Road Treasures from Northwest China*, New York 2001

Royal Academy of Arts, *Return of the Buddha: The Qingzhou Discoveries*, London 2002

Whitfield, R., *The Art of Central Asia: The Stein Collection at the British Museum*, 3 vols, Tokyo: Kodansha International 1982–5

Whitfield, R., *Caves of the Singing Sands: Buddhist Art from the Silk Road*, London 1995

Whitfield, R. & Farrer, A., *Caves of the Thousand Buddhas: Chinese Art from the Silk Route*, London 1990

Zurcher, E., *The Buddhist Conquest of China*, Leiden 1972

Zwalf, W., *Buddhism: Art and Faith*, London 1985

Calligraphy

Barrass, G. S., *The Art of Calligraphy in Modern China*, Berkeley 2002

Fong Wen C. & Murck, A., *The Three Perfections: Poetry, Calligraphy and Painting*, Princeton 1991

Harrist, R. E. & Fong W. C., *Embodied Image: Chinese Calligraphy from the John B. Elliott Collection*, New York 1999

Kraus, R. C., *Brushes with Power: Modern Politics and the Chinese Art of Calligraphy*, Berkeley 1991

Moore, O. *Reading the Past: Chinese*, London 2000

Ceramics

Ayers, J., *Chinese Ceramics in the Baur Collection*, Geneva 1999

Carswell, J, *Blue & White: Chinese Porcelain and its impact on the Western World*, Chicago 1985

Carswell, J, *Blue and White: Chinese Porcelain around the World*, London 2000

Davidson, G., *The Handbook of Marks on Chinese Ceramics*, London 1994

Harrison-Hall, J., *Ming Dynasty Ceramics in the British Museum,* London 2001

He Li, *Chinese Ceramics: The New Comprehensive Survey from the Asian Art Musem of San Francisco*, New York 1996

Kerr, R., *Song Dynasty Ceramics*, London 2004

Kerr, R., *Chinese Ceramics: Porcelain of the Qing Dynasty*, London 1986

Lion-Goldschmit, D., *Ming Porcelain*, London 1978

Los Angeles County Art Museum, *The Quest for Eternity: Chinese Ceramic Sculptures from the People's Republic of China*, Los Angeles 1987

Rinaldi, M., *Kraak Porcelain: A Moment in the History of Trade*, London 1989

Vainker, S. J., *Chinese Pottery and Porcelain*, London 1991

Wood, N., *Chinese Glazes*, London and Philadelphia, 1999

Wood, N., *Glazes: Iron in the Fire*, London 1988

Cloisonné and painted enamels

Brinker, H. & Lutz, A., *Chinese Cloisonné: The Pierre Uldry Collection*, Zurich 1985

Brown, C., *Chinese Cloisonné: The Clague Collection*, Phoenix 1980

Garner, Sir Harry, *Chinese and Japanese Cloisonné Enamels*, London 1962

Daoist art

Kohn, L., *Daoism and Chinese Culture*, Cambridge, Mass. 2001

Little, S., *Taoism and the Arts of China*, Chicago 2000

Little, S., *Realm of the Immortals*, Cleveland 1988

Export art

Ayers, J. & Howard, D., *China for the West*, London and New York 1978

Clunas, C. (ed.), *Chinese Export Art and Design*, London 1987

Clunas, C. *Chinese Export Watercolours*, London 1984

Vollmer. J. E. et. al., *Silk Roads, China Ships: An Exhibition of East-West Trade*, Toronto 1983

Jade

Forsyth, A. & McElney, B., *Jades from China*, Bath 1994

Rawson, J., *Chinese Jade: From the Neolithic to the Qing*, London 2002

Watt, J., *Chinese Jades from Han to Qing*, New York 1980

Wilson, M., *Chinese Jades*, London 2004

Lacquer

Clifford, D., *Chinese Carved Lacquer*, London 1992

Scott, R. et al., *Lacquer: An International History and Collector 's Guide*, Marlborough 1984

Oriental Ceramic Society, Hong Kong, *2, 000 Years of Chinese Lacquer*, Hong Kong 1993

Watt, J. C. Y. & Ford, B. B., *East Asian Lacquer, The Florence and Herbert Irving Collection*, New York 1991

Metalwork

Bunker, E. & White, J., *Adornment for Eternity: Status and Rank in Chinese Ornament*, Denver 1994

Michaelson, C., *Gilded Dragons*, London 1999

Painting

Barnhart, R. et al., *Painters of the Great Ming: The Imperial Court and the Zhe School*, New York and Dallas 1993

Brown, C. & Chou Ju-Hsi, *Transcending Turmoil: Painting at the Close of China's Empire 1796–1911*, Phoenix 1992

Cahill, J., *Chinese Painting*, Geneva 1960, 1985

Cahill, J., *The Compelling Image: Nature and Style in Seventeenth-Century Painting*, Cambridge, Mass. 1982

Cahill, J., *Fantastics and Eccentrics in Chinese Painting*, New York 1967

Cahill, J., *Hills beyond a River: Chinese Painting of the Yuan Dynasty, 1279–1368*, New York and Tokyo 1976

Cahill, J., *The Distant Mountains: Chinese Painting of the Late Ming Dynasty, 1570–1644*, New York 1982

Cahill, J., *The Painters' Practice: How Artists Lived and Worked in Traditional China*, New York 1994

Cahill, J., *Parting at the Shore: Chinese Painting of the Early and Middle Ming Dynasty, 1368-1580*, New York 1978

Fong Wen C., *Beyond Representation*, New Haven 1992

Fong Wen C., *Between Two Cultures*, New York 2001

Fontein, J. & Wu Tung, *Han and T'ang Murals*, Boston 1976

Loehr, M., *The Great Painters of China*, New York 1980

McCausland, S., *First Masterpiece of Chinese Painting: The Admonitions Scroll*, London, 1995

Murck, A., *Poetry and Painting in Song China: The Subtle Art of Dissent*, Cambridge, Mass. 2000

Murray, J. K., *Ma Hezhi and the Illustration of the Book of Odes*, Cambridge 1993

Sickman, L., Ho Waikam, Lee, S. & Wilson, M., *Eight Dynasties of Chinese Painting: The Collections of the Nelson Gallery-Atkins Museum, Kansas City and the Cleveland Museum of Art*, Cleveland 1980

Whitfield, R., *Fascination of Nature: Plants and Insects in Chinese Painting and Ceramics of the Yuan Dynasty*, Seoul 1993

Xin, Barnhart & Chongzheng, *Three Thousand Years of Chinese Painting*, New Haven and London 1997

Symbols and symbolism

Birrell, A., *Chinese Myths*, London 2000

Birrell, A., *Chinese Mythology: An Introduction*, Baltimore 1999

Eberhard, W., *A Dictionary of Chinese Symbols*, London 1986

Medley, M., *A Handbook of Chinese Art*, London 1964, 1973

Pierson, S., *Designs as Signs: Decoration and Chinese Ceramics*, London 2001

Rawson, J., *Chinese Ornament: The Lotus and the Dragon*, London 1990

Williams, C. A. S., *Outlines of Chinese Symbolism and Art Motifs*, Dover 1976

Chronology

Neolithic cultures *c.* 5000–*c.* 1500 BC
 Hongshan *c.* 3500–2500 BC
 Liangzhu *c.* 3000–2000 BC
Shang dynasty *c.* 1500–1050 BC
Zhou dynasty *c.* 1050–221 BC
Qin dynasty 221–210 BC

Han dynasty 206 BC–AD 220
The Six Dynasties 221–589
Sui dynasty 589–618
Tang dynasty 618–906
The Five Dynasties 907–960
Song dynasty 960–1279

Jin dynasty 1115–1234
Yuan dynasty 1279–1368
Ming dynasty 1368–1644
Qing dynasty 1644–1911
Republic of China 1911–1949
People's Republic of China 1949–

Glossary

bi Flat jade disc with central hole, for ceremonial use.

celadon Western term applied to a range of high-fired wares with green coloured glazes that take their colour from small amounts of iron oxides in the glaze.

cong Jade ceremonial object of square section with cylindrical hole, of varying heights.

doucai Decoration outlined in under-glaze blue and then in filled with over-glaze enamels.

enamel colours/enamel painted
Pigments derived from metallic oxides mixed with a glass or glaze-like substance and applied either to a fired ceramic body or over a fired glaze, then fired a second time at a lower temperature. The best known are *doucai*, *wucai*, *famille verte* (*yingcai*) and *famille rose* (*fencai*).

leiwen Angular spirals employed as a background to zoomorphic motifs on bronzes cast in the late Shang and early Western Zhou periods.

lingzhi Sacred fungus (polyporous lucidus) associated with Daoism and symbolic of longevity.

porcelain Vitrified, translucent ceramics fired at a temperature of at least 1280°C.

sancai Literally 'three colours', a lead-glazed palette popular during the Tang period. The three basic colours were green, cream and amber, but blue and black were also used.

shanshui Landscape, literally 'mountains and water'.

shendao 'Spirit way' leading from the gateway to a tomb.

taotie Zoomorphic masks, the most common motif on Shang bronzes.

wenfang sibao Four Treasures of the Writing Studio (*bi* brush, *mo* ink, *zhi* paper, *yan* ink-stone).

wenrenhua Literati painting.

yu Nephrite, jadeite and some other hardstones.

zhuanshu Seal script.

British Museum registration numbers

Chapter 1
OA 1957.5-1.01
OA 1965.10-11.02 (Add 392)
OA MAS 857
OA 1947.7-12.269(a&b)

Chapter 2
OA 1936.10-12.220(5)
OA 1937.4-16.188
OA 1983.3-18.1
OA 1936.11-18.1
OA 1977.4-4.1
OA
OA 1936.10-12.220(5)
OA 1936.10-12.220(25)
OA 1937.7-16.12

Chapter 3
OA 1919.1-1.06
OA 1938.7-15.1
OA 1919.1-1.01
OA 1919.1-1.06
OA 1919.1-1.047
OA (Ch. 00260)
OA 1913.11-21.1
OA 1919.1-1.045
OA 1981.2-7.1
OA 1917.11-16.1
OA 1988.7-27.1
OA 1939.1-18.1

Chapter 4
OA 1974.2-26.19
OA 1955.10-24.1
OA 1968.4-22.10
OA 1936.10-19.1
OA 1975.10-28.19
OA 1947.7-12.182
OA 1968.4-23.2
OA 1949.12-13.1
OA 1957.5-1.1
OA 1974.2-26.19
OA 1989.6-14.1
OA 1961.5-18.1

Chapter 5
Private collection
Private collection
Private collection
Private collection
OA 1937.4-16.218
OA 1883.10-20.5
OA 1940.6-5.1
OA 1903.4-8.1
OA MAS 857
OA 1998.11-12.01
OA 1980.3-27.1
OA 1965.10-11.02 (Add 392)
OA 1943.2-15.30
Private collection
OA 1936.4-13.44

Chapter 6
OA 1954.11-13.05
OA 1993.7-6.026
OA 1946.7-15.1
OA 1936.10-12.169
OA 1936.10-12.206
OA F1670
OA 1947.7-12.269(a&b)
OA 1983.4-20.1
OA 1931.11-117.1(b)
OA
OA 1954.11-13.05
OA 1928.3-23.040
OA 1993.7-6.036
OA 1987.12-24.010

Index